The Nude

UNDERSTANDING THE ELEMENTS OF LIFE DRAWING

Giovanni Civardi

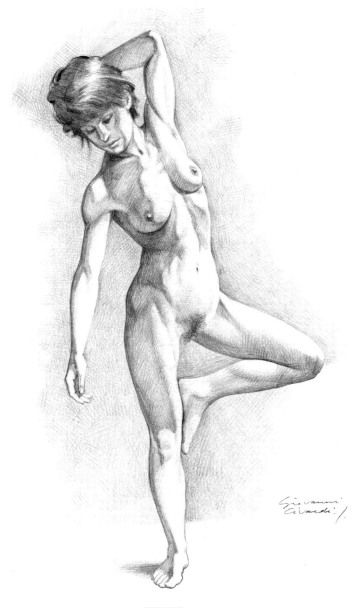

SEARCH PRESS

Giovanni Civardi was born in Milan in 1947.
After first dedicating himself to illustration and sculpture,
the author turned to anatomy for the artist and has been
running courses in figure drawing for many years.

Lack of life is mainly revealed
by lack of dialogue.
 Aldo Carotenuto

Part of our lives – even those barely worthy of
consideration – is spent searching for reasons to
exist, starting points and sources.
 Marguerite Yourcenar

Half open and half hid;
the less she shows, the lovelier she.
 Torquato Tasso

First published in Great Britain 2007 by Search Press Limited,
Wellwood, North Farm Road, Tunbridge Wells, Kent TN2 3DR

Originally published in Italy by Il Castello Collane Tecniche,
Milano

Copyright © Il Castello S.r.l., via Scarlatti 12,
20090 Trezzano sul Naviglio (Milano), 2006 *Il Nudo*

Translated by Linda Black in association with First Edition
Translations Ltd, Cambridge, UK

Typeset by GreenGate Publishing Services, Tonbridge, Kent

English translation copyright © Search Press Limited 2007

ISBN-10: 1-84448-244-8
ISBN-13: 978-84448-244-3

The figure drawings reproduced in this book are of
consenting models or informed individuals: any
resemblance to other people is by chance.

CONTENTS

INTRODUCTION

*Perhaps we only learn something we already knew:
the master merely sheds light on a dark corner
where a hidden instinct is waiting to become an idea.*
Lorenzo Vespignani

Drawing the human form involves every part of us: it is about our feelings towards the models as we observe their physical features and sense their moods, comparing them with our own. As with portraits, but to an even greater extent, looking at the bodies of our fellow creatures allows us, in a sense, to catch a glimpse of their life force. Our work represents our attempts to reflect and project this force.

It is therefore neither surprising nor a secret that since the first upsurge of artistic and religious feeling, portraying the human body has been one of the most important themes. The nude figure sums up the essence of humanity, although it has of course been depicted differently in western and eastern civilisations. In the former, for example, a distinctive feature is the stress on analysis, on description, on anatomy, on explaining the organic structure and on reconciling general and individual characteristics. In the latter the focus is on the subject's life force, on any subtle but revealing signs of their internal energies.

Drawing figures, then, is a centuries-old practice for training western artists and is an accepted teaching convention even today. In these times of extremely varied aesthetic trends and artistic means of expression, we still consider drawing from live models a very worthwhile discipline.

There are various teaching methods for drawing nude figures, all of which basically rely on two main approaches. The structural approach follows scientific principles and encourages the artist to concentrate on the constructive (anatomical, technical and geometric) qualities of the model. For example, this involves establishing the length of the segments of the body, the direction of the main axes, the correct proportions, contours and areas of volume. In contrast, the expressive approach tends to concentrate on a more spontaneous view of the figure, on capturing the qualities, emotions and character that lie within rather than on the body's organic structure. The two ends of the spectrum can and must, of course, complement each other to varying degrees, depending on each artist's artistic temperament and attitude.

I thought it useful, therefore, to set out here some topics to consider when drawing nude figures. These topics will suggest a series of routes that you could take to learn to observe, as if for the first time, with fresh eyes, both male and female human bodies.

When portraying objects in any medium, dividing them according to type or subject matter (still life, animals, landscapes and figures) is somewhat arbitrary. The principle is the same and applies to any object. Observing means 'looking carefully and with wonder'; seeing the relationships between the individual parts and the whole; capturing the 'character' of the object in question; and allowing yourself to feel and to understand. Figure drawing in particular presents many challenges and the ability to perceive and observe varies widely between individuals.

Detailed anatomical knowledge is less important than morphology in understanding and explaining the human form. Human figures are three-dimensional bodies: solid structures with depth, volume and weight. To draw them convincingly you need to learn to create, on a flat piece of paper, the illusion of a solid shape. Having mastered the basic shape, you can then interpret the figure, both subjectively and creatively, through analysis of anatomy, perspective, light and shade. For example, careful observation alone can be sufficient to identify at what points of the body the skeleton appears beneath the surface. A knowledge of anatomy can further confirm the accuracy of the impression, of the visual analysis, but these facts still need to be expressed artistically, plastically and graphically. In short, an entirely 'scientific' rendering can appear unnecessarily academic and laboured, lacking in character. Accuracy need not mean pedantry or slavish imitation. A solid background knowledge can instead reveal itself in simplicity.

SOME PRACTICAL CONSIDERATIONS

But when something bores you,
leave it alone.
Eugène Delacroix

FINDING MODELS

Figures are usually drawn from life during leisure or educational courses at art schools or colleges, located in most towns and cities. You can contact these institutions to find out about courses and get in touch with both male and female models. If there are no art schools near you, you can still arrange 'nude' sittings, perhaps by getting together with other artists and posing for each other. Always ensure you choose premises with enough room to accommodate both artists and models comfortably. Whatever the circumstances, models must be treated correctly; remember to check legal requirements regarding age, and reach clear agreements about fees, the place and the length of the sitting, the purpose of the drawings, confidentiality, and so on.

WHICH MODELS?

It is not necessary to always look for professional models, i.e. people who normally model at art schools or are sent by employment agencies. Nor does the model have to be young or have an 'ideal' body shape which meets current aesthetic standards. 'Normal' individuals are much more interesting and full of character: quite often the most suitable and willing models can be found at dance, physical training or acting schools. However, studying 'nude' figures does not always require full nudity: modern-day swimming costumes are more than enough to safeguard the subject's modesty and allow extensive bodily expression. The key qualities for a model are friendliness, patience and willingness to participate. Usually, the spontaneity of the pose, working together in harmony and being 'involved' in a project compensate in full for any lack of 'experience at posing'.

WORKING ENVIRONMENT

The area intended for nude sittings must have: a separate corner where the model can undress and get dressed again; sufficient heating; and a set of props for assuming the various poses. It is preferable to have natural light or daylight (not direct sunlight), if possible coming from a large window (old masters used to choose the light from the north). Artificial light is also suitable, provided it is not emitted from multiple sources, which would cancel out the shadows on the model or create complicated ones. If this happens, you should add some medium-intensity lamps aimed directly and appropriately at the model, in such a way that they do not bother him or her, or produce unpleasant shadowy effects. A sitting normally lasts upwards of a couple of hours, with quarter-hour breaks every hour or so, depending on the pose. Some soft music can make the time pass pleasantly for both artists and models.

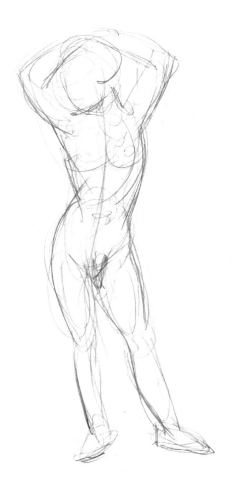

1 Overall outline

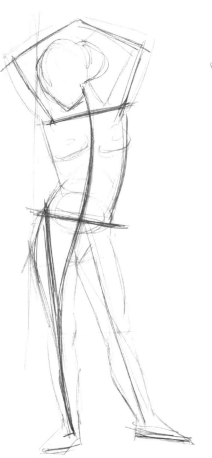

2 Identifying structural lines

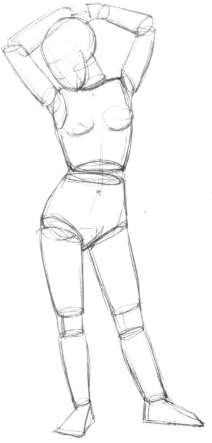

3 Geometrising

DISTANCE FROM THE MODEL

The optimum distance from the model is 2–3 metres (80–120in), so that you can see the whole body without having to move your eyes or head too much. Not all working environments allow every artist to work at the right distance: it is important, therefore, not to alter the perspective too much (unless this is what you are trying to achieve) and to be able to change your viewpoint by going around the model, sitting on the floor or standing on a raised surface.

TECHNIQUES TO USE

Nude studies are seen as exercises in *observing* the model and are therefore usually carried out using 'graphic' techniques, which are simple and immediate (pencil, charcoal, pen and ink, pastels, coloured pencils, etc.). In some cases, however, they can be preparatory drawings for more complex works (paintings or sculptures), which was common practice in the past. It is useful to rest the paper on an easel, so the paper remains vertical and, therefore, parallel to the model. If you are sitting down, however, it is often easier to hold the paper in place on a medium-sized (30 × 40cm or 40 × 50cm [12 × 16in or 16 × 20in]), for example) lightweight board, which you can rest on your lap.

CULTURAL REFERENCES

Studying nude figures from life can become more rewarding if combined with studying anatomy, history of art, philosophy or psychology. These 'cultural' combinations can help to inform your drawing; their influence can vary in strength and direction according to each individual. They should, however, be subordinate to direct and careful *observation* of the human body; your aesthetic impulses should be primarily your own. The combination of in-depth knowledge and complementary sources of inspiration should be aimed at bringing out and developing each artist's personal expressive style, according to the following sequence: observing, understanding and interpreting.

WORKING IN A GROUP

Drawing alone is essential for furthering the creative process, but drawing in the company of other artists offers many advantages, especially when the group is small (ten members at most) and is made up of people with varied artistic experiences. Before the sitting, you could make some group decisions, such as deciding on the pose, which position to draw from, the type of lighting and so on. During the sitting you could look over each other's shoulders and find ideas for new technical solutions or new styles of drawing. At the end of the sitting, you could compare and criticise each other's drawings, exchange opinions, suggest projects or alternative ways of studying. The greatest advantage of group work is sharing the cost of the model and the mutual encouragement it brings.

The sketches reproduced here show one of the possible sequences for portraying the human body in drawings and sum up the main successive phases of observing and analysing the figure: from perceiving the overall form and its character, to examining the structural components, to modulating tonal planes and surface peculiarities.

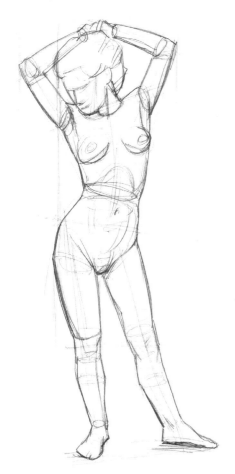

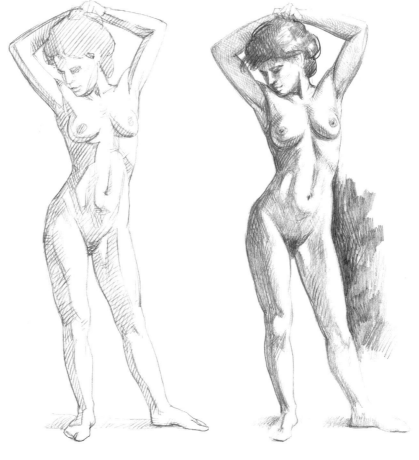

4 Simplifying the organic form *5 Indicating the main areas of volume* *6 Modelling surfaces*

THE MAIN FORM

The most spontaneous and immediate drawings, known as *gestural* drawings, are rapid sketches based mainly on careful observation, which are intended to record as much 'information' as possible in a short time. The need (whether imposed or preferred) to produce a quick 'portrait' of the figure prompts the artist to be alert (almost as if in a 'state of emergency') and encourages him to capture, in an intuitive, but accurate, way, the most important characteristics, including the form and posture, of the body being studied.

This results in a synthetic drawing in which the aesthetic outcome is entirely secondary: its purpose is to show the artist's intention to express in full the structure, posture or action of the subject being portrayed. After all, to draw well, it is essential to learn to see.
A gestural drawing is not a goal in itself, but is a way of learning, of practising careful observation and co-ordinating what your eyes perceive with what your hand draws on the paper. In short, it is a way of acquiring experience and a 'freshness' that is inevitably reflected in even the most elaborate and complex final drawings.

Simple and expressive
Giuseppe Verdi

For a gestural drawing to become a useful exercise, some of the following practical issues need to be considered:
• The model should pose for 2–5 minutes.
• Carefully observe the 'character' of the entire figure, in terms of posture and form, and focus on the model rather than the drawing.
• Assess the axes of the trunk and limbs (i.e. the internal structure 'lines' originating especially from the position of the pelvis and spine); the areas of 'tension' between the various body segments; the equilibrium of the body and the direction of the movement or gesture; the contours of the forms.
• Use ordinary sheets of paper of average size (for example: 25 × 35cm or 35 × 50cm (10 × 13¾in or 13¾ × 20in), resting on a solid board, and tools that make it easy to apply repeated strokes, both lightly (or energetically) and densely (for example: soft graphite leads, compressed charcoal and felt-tips).

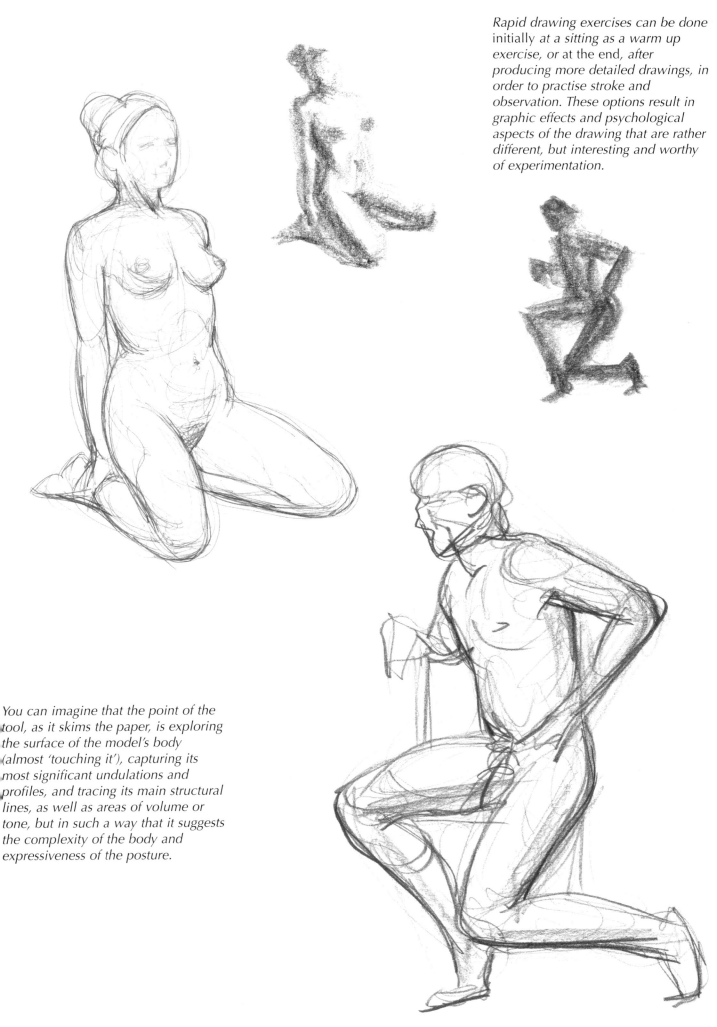

Rapid drawing exercises can be done initially *at a sitting as a warm up exercise, or at the end, after* producing more detailed drawings, in order to practise stroke and observation. These options result in graphic effects and psychological aspects of the drawing that are rather different, but interesting and worthy of experimentation.

You can imagine that the point of the tool, as it skims the paper, is exploring the surface of the model's body (almost 'touching it'), capturing its most significant undulations and profiles, and tracing its main structural lines, as well as areas of volume or tone, but in such a way that it suggests the complexity of the body and expressiveness of the posture.

MEASUREMENT

In the human figure, the dimensions of each part relate closely to those of the other parts and are in proportion to the whole body. These relationships are based on the anatomical structure in proportions defined by anthropometry, but also look forinspiration from aesthetic principles of ideal beauty. You will see in the next chapter that physical proportions are more difficult to perceive and evaluate if the figure has assumed a complex pose or is viewed from an unusual perspective. Especially here, therefore, when studying forms that correspond to objective anatomical and morphological features, you may need to take measurements that will enable you to draw a convincing portrait of the subject on paper. One easy and intuitive method is to consider some important stages for assessing relationship between dimensions and suggesting the figure's direction in space:

I learned to measure and see and to look for the main lines
Vincent Van Gogh

1 – Indicate the points that 'jut out the most' on the sheet – the top and bottom ones (maximum height), those at each side (maximum width) and the middle point, where the perpendicular lines joining up these points cross.

2 – Assess the vertical and horizontal alignments by identifying some reference guidelines (the margins of the sheet, for example, or vertical and horizontal lines present in the surroundings) and measuring the distances between these and the most obvious anatomical or morphological points on the figure.

3 – Assess the oblique lines that, depending on the posture assumed by the model, correspond to the axes of the main body regions. Evaluate the width of the angles formed between these lines, in relation to the vertical and horizontal alignments. Measuring should not, however, become a bugbear for the artist: rather than being a pedantic survey, it should be an exercise in comparing dimensions and distances, aimed at developing a good ability to 'roughly' measure ('knowing how to make a good rough estimate', as Michelangelo used to say), supported by real checks in case of doubt or difficulty.

a – If your eye is positioned horizontally, level with the centre point of the model (especially if the model is standing up straight), the perceived dimensions appear correct; if the eye is positioned above or below this point the perspective can change.

b – Using a very simple, old and intuitive procedure, you can measure 'by sight'. Hold a pencil or measuring rod with your arm outstretched in the model's direction. Close one eye, then make the top of the rod match one end of a body segment, and run your thumbnail down until you reach the other end of the body segment. Compare this measurement with that of other body segments or sections and transfer it to the paper.

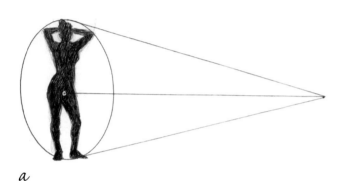

a

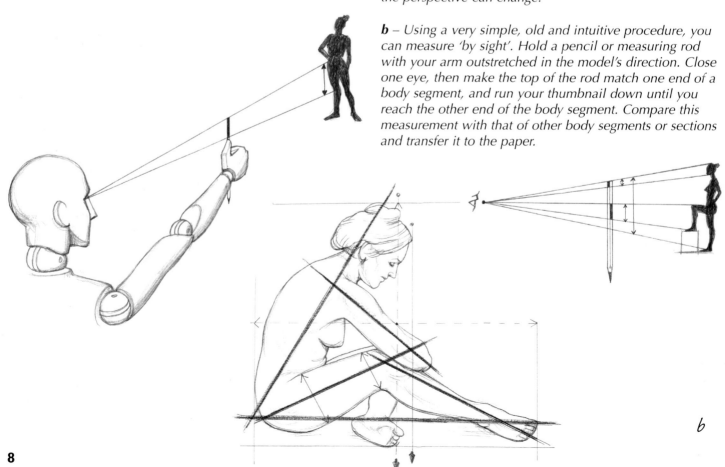

b

8

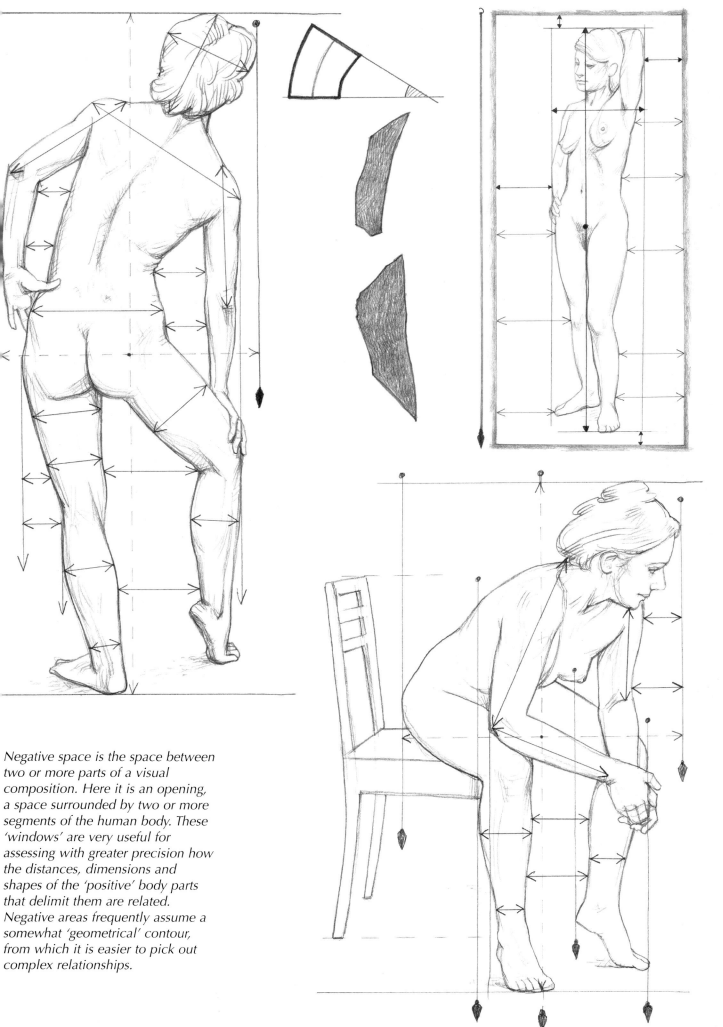

Negative space is the space between two or more parts of a visual composition. Here it is an opening, a space surrounded by two or more segments of the human body. These 'windows' are very useful for assessing with greater precision how the distances, dimensions and shapes of the 'positive' body parts that delimit them are related. Negative areas frequently assume a somewhat 'geometrical' contour, from which it is easier to pick out complex relationships.

PROPORTION

Proportion can be defined as the way in which the dimensions of the individual parts of the body relate to each other and to the figure as a whole. From these relationships it is possible to infer a *standard*, i.e. a set of rules, that make it easier for the artist to portray the human body in accordance with anatomy and anthropometry (the comparative study of sizes and proportions of the human body). These rules can be adapted to allow the artist to portray an aesthetic ideal of beauty.

The schematic drawings here refer to a simple 'scientific' standard (deduced from average statistics for the body's dimensions) for both the male and female adult figure, when standing up straight. The unit of measurement chosen is the head, measured from the tip of the chin to the top of the skull. It is then easy to see that the height of the body corresponds to around seven-and-a-half times the unit of measurement; that the maximum width, at the shoulders, is equal to two units of measurement, etc. The halfway point of the body's height is situated at the lower end of the abdomen. In men it is roughly level with the groin; whereas in women it is situated a little bit higher.

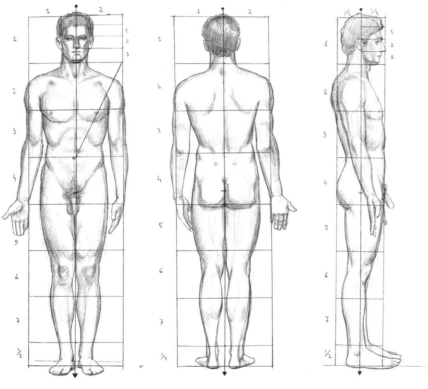

The vertical and horizontal lines form a grid in which it is easy to place the main anatomical references and show the relationships between the various body parts: the middle vertical line (in the front and back projections) divides the body into two halves that can be considered symmetrical.

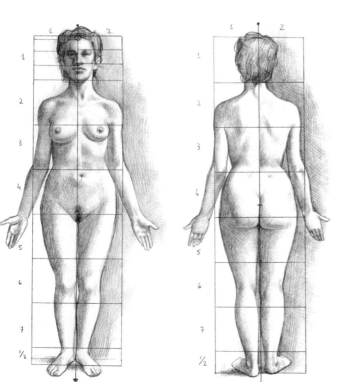

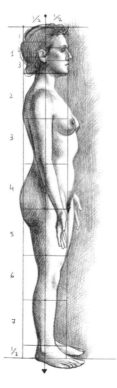

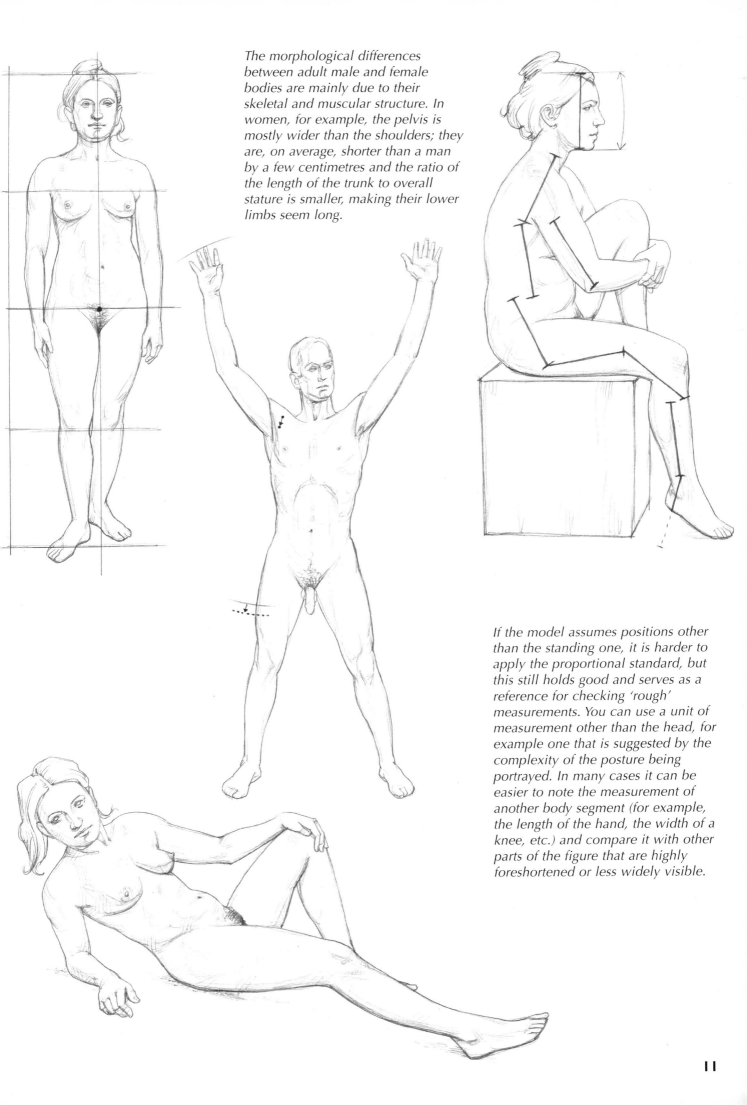

The morphological differences between adult male and female bodies are mainly due to their skeletal and muscular structure. In women, for example, the pelvis is mostly wider than the shoulders; they are, on average, shorter than a man by a few centimetres and the ratio of the length of the trunk to overall stature is smaller, making their lower limbs seem long.

If the model assumes positions other than the standing one, it is harder to apply the proportional standard, but this still holds good and serves as a reference for checking 'rough' measurements. You can use a unit of measurement other than the head, for example one that is suggested by the complexity of the posture being portrayed. In many cases it can be easier to note the measurement of another body segment (for example, the length of the hand, the width of a knee, etc.) and compare it with other parts of the figure that are highly foreshortened or less widely visible.

EXTERNAL STRUCTURE: GEOMETRISING

Geometrising is an abstraction process whereby complex forms (especially those relating to biological organisms) are likened to the shapes of the simplest geometric solids: spheres, cubes, cylinders, pyramids, etc.

You start by choosing the geometric shape that best corresponds to or describes a whole organic shape or one of its segments. At first this is just an approximation but it can help to clarify the form of the individual, their position in space, the ways in which their body segments are divided and their relative proportions. Geometrising forms is particularly useful for correctly conceptualising the figure when it is seen as foreshortened (cf. page 20): it is easier to put geometric solids – rather than complex and less regular forms – in perspective. In these cases it can be useful if you have access to a well-made and correctly jointed wooden manikin. When drawing nude figures, especially, it is very important to suggest the 'solidity' of the body, defining its areas of volume rather than simple contours. Geometrising is equally useful for correctly perceiving and effectively expressing the effects of light, shade and reflection. These effects, of course, can be easily identified if you first refer to surfaces on geometric solids and then transfer them to similar body shapes accordingly.

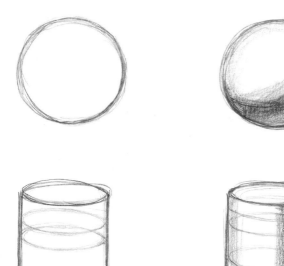

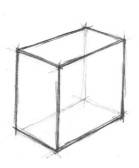

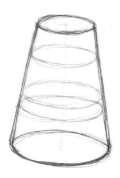

a – *To represent volume and surface development characteristics effectively, it can be helpful to imagine a series of cross-sections on the solid, according to a succession of 'level lines' that wrap around it. If you imagine the solid to be transparent, you would be able to add where the lines would appear on the parts that are not directly visible as well. On the human body, the section lines at various levels are more complex, but follow the same principles.*

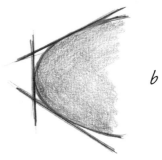

b

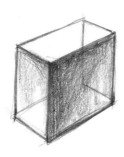

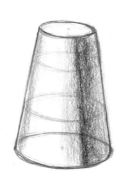

a

b – *A curved line can also be suggested by a sequence of short straight lines at various angles. This suggests the solidity of the shape and gives it a more genuine sense of volume or depth.*

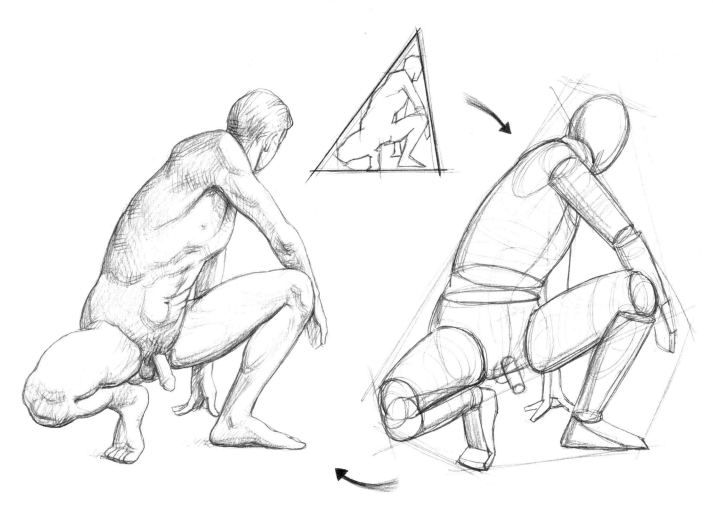

The posture of the whole body almost always suggests an overall shape, the outline of a flat geometric figure such as a circle, triangle, ellipse, square and so on, into which it can be inserted.

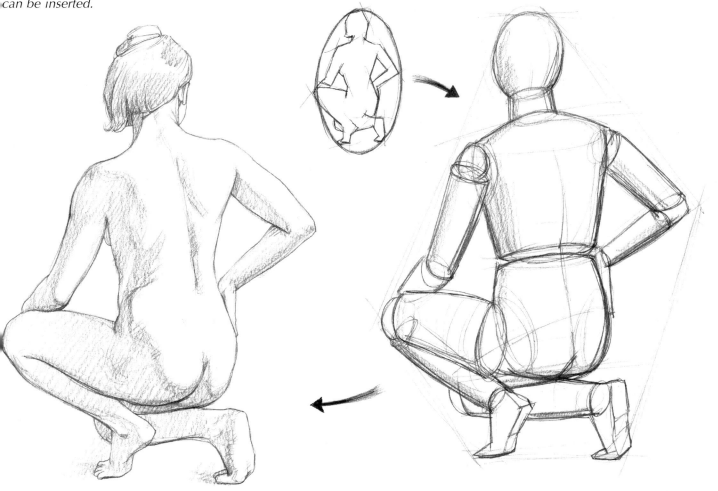

INTERNAL STRUCTURE: ANATOMY

To describe the external forms of the human body in an appropriate and convincing way, it is useful, if not essential, to be familiar with the form, position and function of the elements that make up the internal structure, particularly those concerned with movement: the bones, joints and muscles. Anatomy is a scientific discipline, but it is of great interest to the artist, not only for cultural, historical and philosophical reasons but also because it helps produce a skilful portrayal of the nude figure. Anatomy, in short, should be seen as a tool at your disposal (if you wish to use it) to understand yourself and your body better, and to improve your life drawing. Exact, exhaustive scientific information can be used to 'fully justify' body shapes and explain them better, but this is secondary to a thorough understanding gained through careful observation.

Please note: much has been written about the importance of anatomy to life drawing. I would only like to mention it briefly here and ask that you examine it more closely elsewhere.

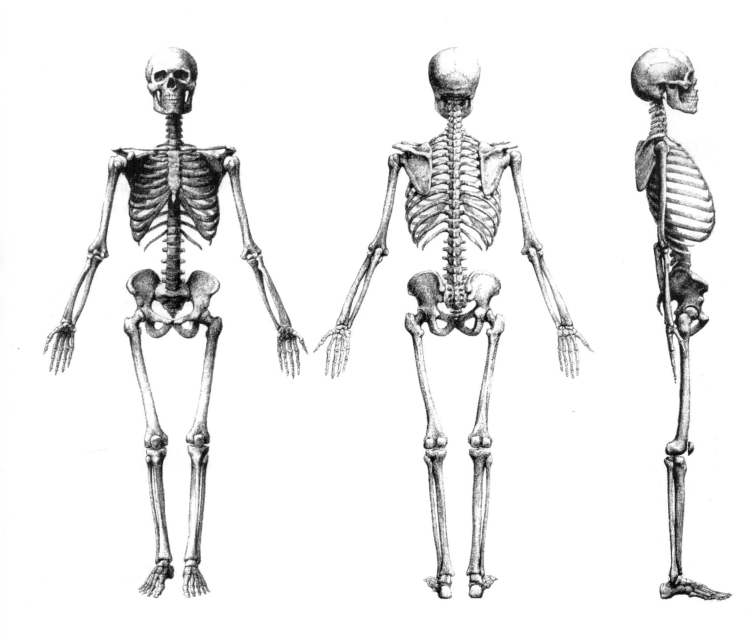

The skeleton is the weight-bearing element of our body, consisting of over 600 bones connected by joints. The skull, the spine, the ribcage and pelvis make up the axial skeleton. The bones of the lower limbs and upper limbs, the clavicle and scapulae, make up the appendicular skeleton.

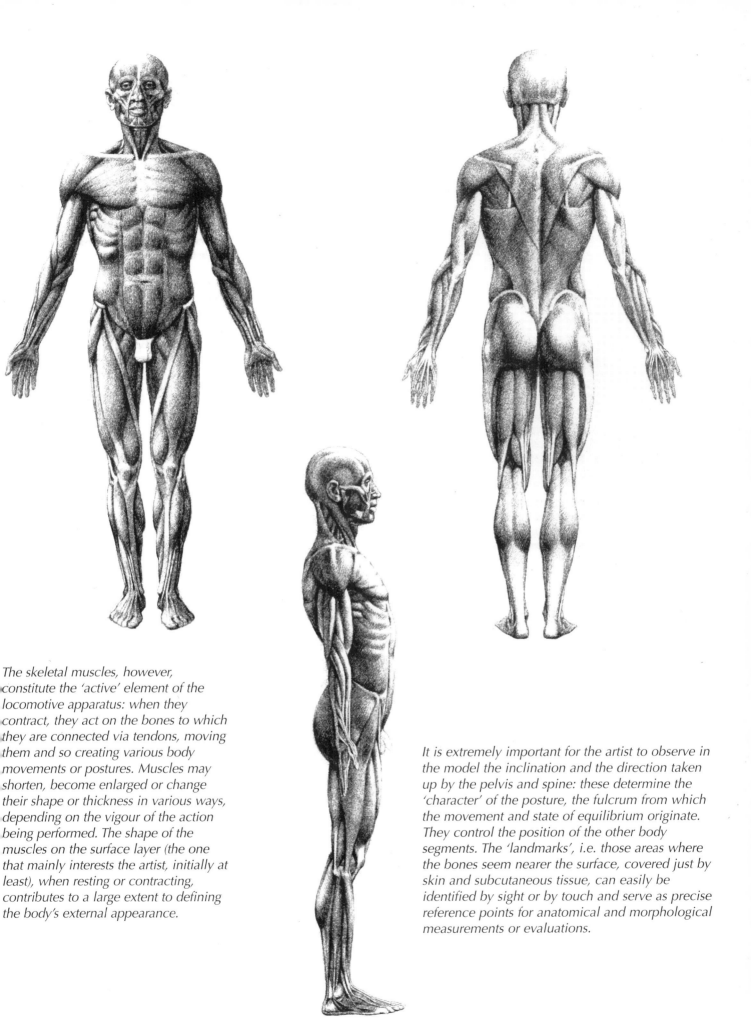

The skeletal muscles, however, constitute the 'active' element of the locomotive apparatus: when they contract, they act on the bones to which they are connected via tendons, moving them and so creating various body movements or postures. Muscles may shorten, become enlarged or change their shape or thickness in various ways, depending on the vigour of the action being performed. The shape of the muscles on the surface layer (the one that mainly interests the artist, initially at least), when resting or contracting, contributes to a large extent to defining the body's external appearance.

It is extremely important for the artist to observe in the model the inclination and the direction taken up by the pelvis and spine: these determine the 'character' of the posture, the fulcrum from which the movement and state of equilibrium originate. They control the position of the other body segments. The 'landmarks', i.e. those areas where the bones seem nearer the surface, covered just by skin and subcutaneous tissue, can easily be identified by sight or by touch and serve as precise reference points for anatomical and morphological measurements or evaluations.

SYMMETRY AND ASYMMETRY

Obliquity expresses action
Rudolf Arnheim

The concept of *symmetry* (a term which, originally, simply meant a 'correct proportion') is closely linked with that of equilibrium, although equilibrium does not necessarily require a symmetrical arrangement for it to exist. Symmetry can be *central* (as in crystals) or *axial*, where the forms on a given plane are distributed as a mirror image either side of a straight line or axis of symmetry. This is the most frequent arrangement for organic forms and, therefore, for the human body as well. If we observe, from the front or back, the body standing up straight (the 'anatomical' position), we easily notice that a hypothetical vertical plane divides the form down the middle, with the right half a twin to the left, although not a perfectly identical match. The side view of the body, however, does not present any symmetry between the front half and back half. Symmetry and equilibrium are not only connected by the physical principles of gravity, but also by 'visual perception' principles, especially those of weight and directionality. Thus *visual weight* depends on the way in which each element (position, distance, colour or tone, mass, etc.) of a composition is arranged in the picture; *directionality*, or the arrangement of the elements according to direction lines, can produce 'dynamic' symmetrical or asymmetrical forms, laden with tension or equilibrium. We associate symmetry with the inability to change, with stability or being static, and for this reason it is only seldom sought in human figure drawing. Relative asymmetry is preferred, suggesting movement or dynamic tension.

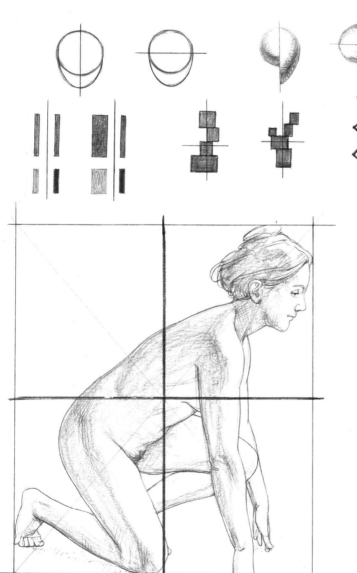

It may be useful, when deciding how to compose the posture of a nude figure, to do a few 'abstract' experiments, comparing and assessing the effects of very simplified areas of volume or tone, arranged both symmetrically and asymmetrically. When drawing and painting, it is useful to analyse symmetry, but it is essential to set out actual body weights when intending to model or sculpt the figure.

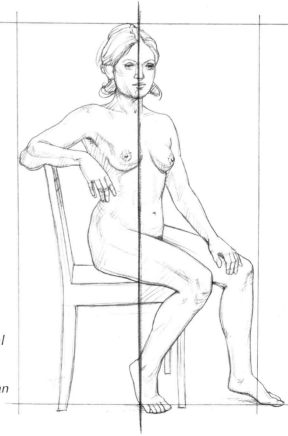

A vertical line (or the crossing point of two perpendicular lines) in the centre of a figure composition helps us to judge the degree of symmetrical arrangement, not of the single body elements, but of the main masses containing them. In these two sketches, the area occupied by the body in the right half of the drawing is largely offset by that in the left half. This can also apply to diagonal or horizontal subdivisions.

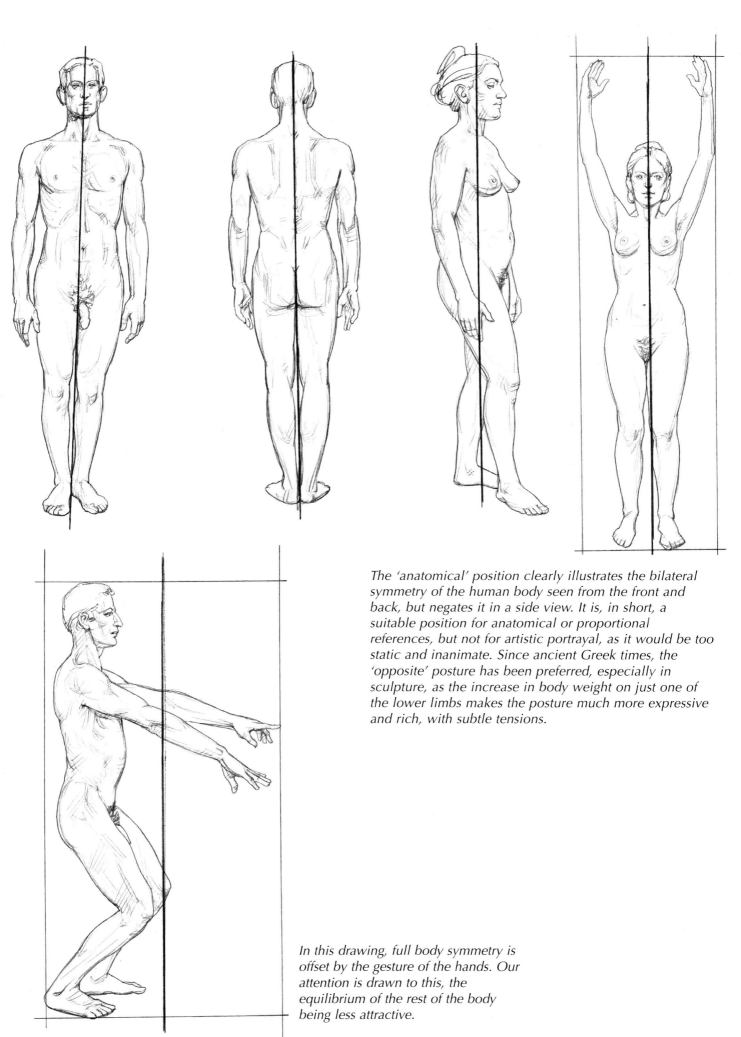

The 'anatomical' position clearly illustrates the bilateral symmetry of the human body seen from the front and back, but negates it in a side view. It is, in short, a suitable position for anatomical or proportional references, but not for artistic portrayal, as it would be too static and inanimate. Since ancient Greek times, the 'opposite' posture has been preferred, especially in sculpture, as the increase in body weight on just one of the lower limbs makes the posture much more expressive and rich, with subtle tensions.

In this drawing, full body symmetry is offset by the gesture of the hands. Our attention is drawn to this, the equilibrium of the rest of the body being less attractive.

EQUILIBRIUM AND BALANCE

Equilibrium, in the physical and mechanical sense, is linked to the position of the centre of gravity, the barycentre, where the body's mass is concentrated. The human figure is continually subjected to mechanical forces (gravity, translation, friction, etc.): if the forces cancel each other out, they 'balance'; there is a state of equilibrium. Without any external assistance or support, the human body maintains its equilibrium with continuous adjustments and, thus, the line of gravity falls within the standing area on the ground. For example, when someone is standing upright, the support area is defined by the outer contour of the feet and includes the area between them. Balance, then, enables us to maintain our posture without falling, both when standing still and moving about. Obviously, when there is wide stability (for example, when someone is sitting or lying down), there is less need for balance. Various body segments (head, trunk, lower limbs, etc.) each have their own centre of gravity and axis: placed on top of each other, vertically, they describe, as a whole, a line broken into segments angled from front to back, to various degrees. The spine is flexible but strong, anchored to the pelvis: it is the main element for achieving equilibrium and balance, and is also the most interesting structure for describing them effectively in a drawing. In most cases, to confirm that the apparent equilibrium in the drawing matches the model's actual equilibrium, you need only to identify the approximate centre of gravity (it can be projected from a point just below the navel), and draw the line of gravity from this point down to the ground: if it falls inside the support area the body is correctly balanced; if it falls outside the area it means that the body is not balanced or that it is trying to balance by moving other body parts.

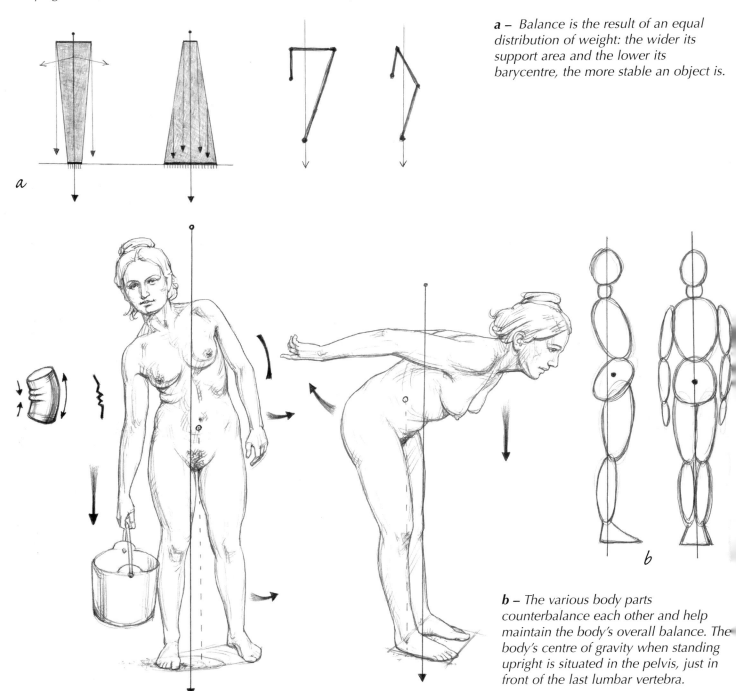

a – Balance is the result of an equal distribution of weight: the wider its support area and the lower its barycentre, the more stable an object is.

b – The various body parts counterbalance each other and help maintain the body's overall balance. The body's centre of gravity when standing upright is situated in the pelvis, just in front of the last lumbar vertebra.

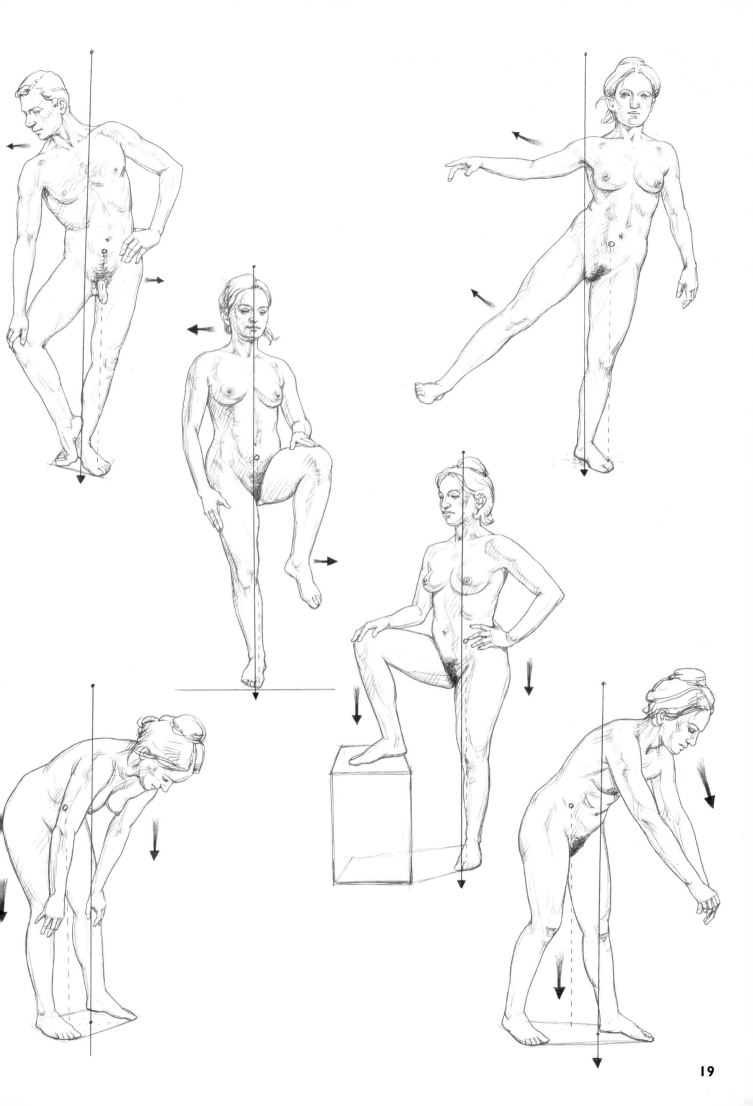

PERSPECTIVE AND FORESHORTENING

Perspective is a graphic means of representing depth in space on a flat surface: the effect of receding into the distance is obtained (in linear perspective) by reducing the size of the objects represented. The human body is mainly put 'in perspective', by using angular (or oblique) perspective, involving two vanishing points towards the ends of the horizon line. We can imagine the body as if it were enclosed in a kind of box, from which it is easy to achieve perspective projection: it is enough as a first

approximation to give just a few ideas on 'intuitive' perspective.

It is worth noting that the human figure is almost always, to some extent, seen and represented in foreshortened conditions. *Foreshortening* is the perspective effect of obliqueness; where all the parts of the body positioned on a horizontal plane, which is not parallel to the projection plane, appear to have their proportions altered to varying degrees or are partly overlapped by other parts.

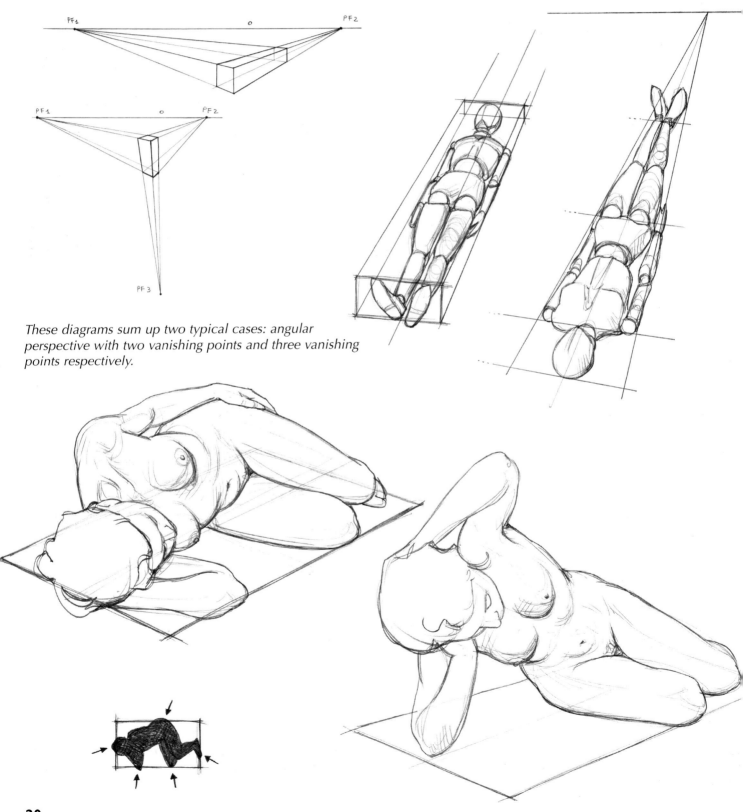

These diagrams sum up two typical cases: angular perspective with two vanishing points and three vanishing points respectively.

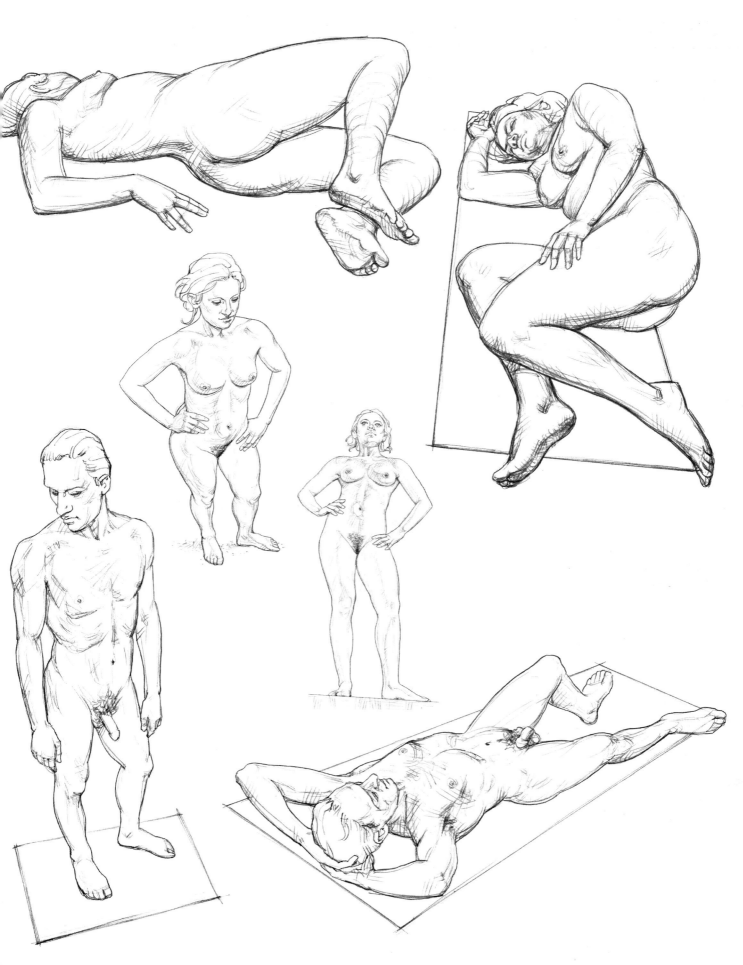

To capture the effects of perspective on the body, it is sometimes useful to have the model lie down on top of a simple geometric shape (a square, rectangle, etc.) that can very easily be put in perspective. Objects often used for this purpose include rugs, rectangular sheets of newspaper or wrapping paper, a tabletop or a mat.

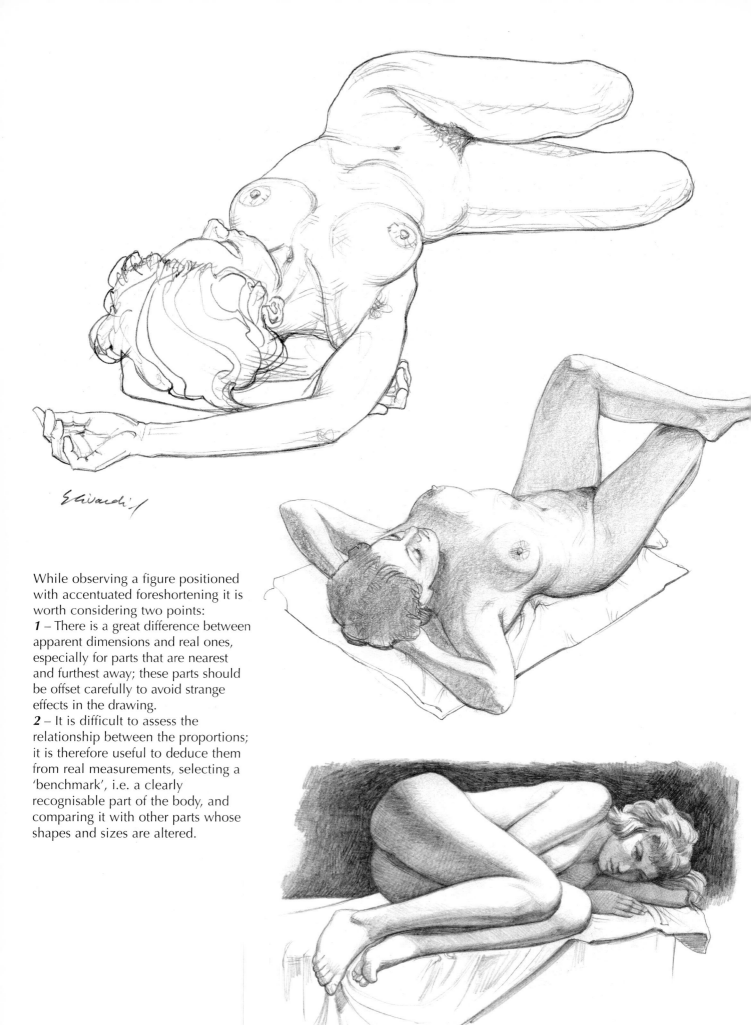

While observing a figure positioned
with accentuated foreshortening it is
worth considering two points:
1 – There is a great difference between
apparent dimensions and real ones,
especially for parts that are nearest
and furthest away; these parts should
be offset carefully to avoid strange
effects in the drawing.
2 – It is difficult to assess the
relationship between the proportions;
it is therefore useful to deduce them
from real measurements, selecting a
'benchmark', i.e. a clearly
recognisable part of the body, and
comparing it with other parts whose
shapes and sizes are altered.

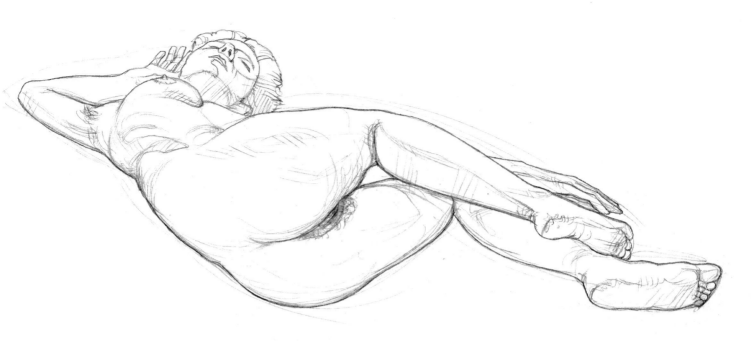

The effect of receding in space can also be obtained by partially overlapping various body sections and drawing those nearest the observer more sharply and with more detail than those further away: a sort of weak 'aerial perspective' between the ends of the body. The volume and roundness of the shapes can be suggested not only through moderate 'geometrising', but also by adding a series of faint 'level lines' to the surface of the body segment being drawn (cf. page 12).

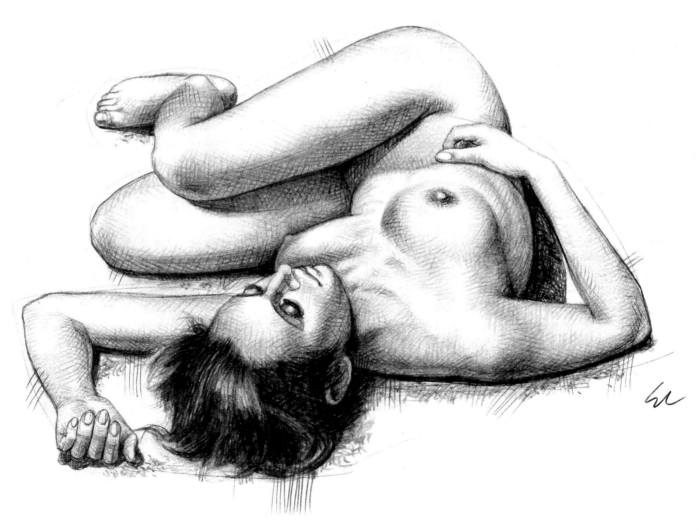

LIGHT AND SHADE

Light moulds the shape of the human body by creating the corresponding *shadows*, just as it does any other object that is illuminated. We know that light can be natural (sun) or artificial and it can hit the surface at various angles and with various degrees of intensity or concentration (direct, diffuse, weak, strong, etc.), and that the shape and direction of the shadows indicate the intensity and position of the light source. In short, light and shade are crucial factors not only for emphasising three-dimensional shapes and putting them into relief, but also for giving the feeling of volume and the idea of space and depth.

The play of light and shade is achieved, in drawings, through *chiaroscuro*, i.e. by means of graduating tones that are shaded off via a sequence of middle values between the lightest and darkest tones. Here are a few ideas to consider when drawing a nude figure:

1 – Illuminate the model with a rather diffused light, from just one moderately strong source.

2 – Assess the middle tone (the 'local' tone), and then identify and show the main areas of maximum light and most intense shadow, thus defining the extreme values of the tonal range.

3 – Pay close attention to the line separating the illuminated areas from the shadowy areas, and to reflected light and cast shadow.

4 – Organise the layout of the light and dark areas, on the body as well as in the surroundings: if they are alternated or contrasted, it can contribute to the composition of the drawing through areas of varying visual weight.

half-shadow (half-tone)

shadow line (hump, crest, bridge)

reflected light

highlight (maximum light), shine

form shadow (shading)

cast shadow (projected)

penumbra (outer shadow)

The sketch reproduced here is taken from one of my previous books (Drawing Light & Shade – Understanding Chiaroscuro) *in this same series: it sums up chiaroscuro terminology and is easy to understand.*

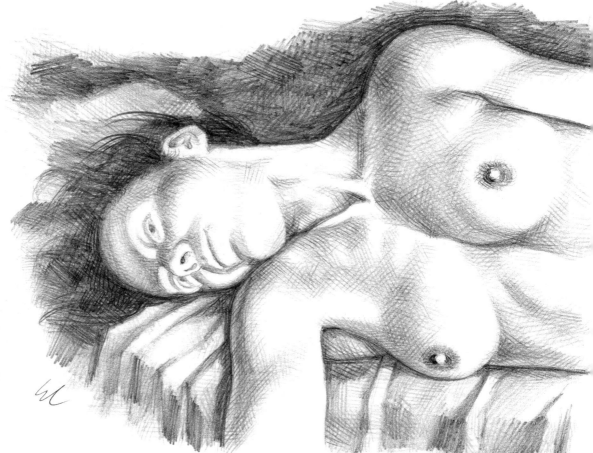

Shadows can produce dramatic and very expressive effects, particularly if the light comes from a rather unusual direction.

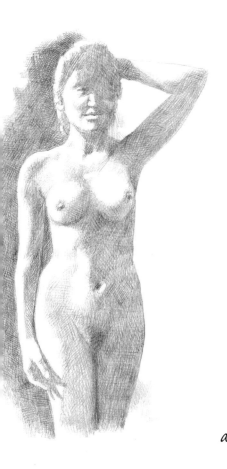

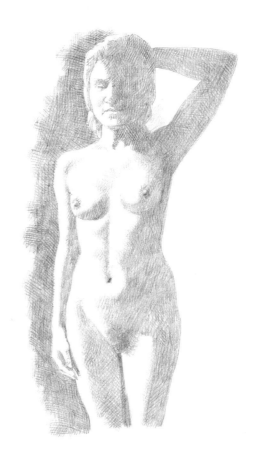

a

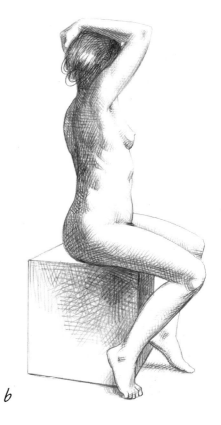

a – Various effects of relief when the figure is facing two different ways, but in the same pose, and with the light coming from the same direction.
b – A different contrast effect on the figure, compared with the background tone.
c – Results produced by weak, diffuse light and strong, direct light.

b

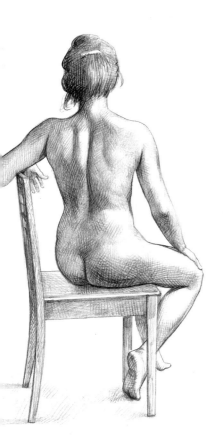

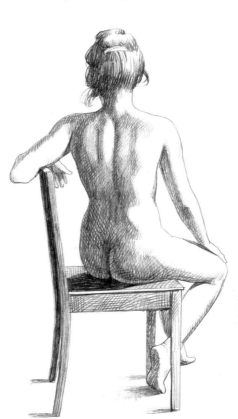

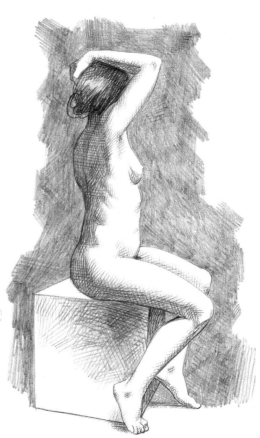

c

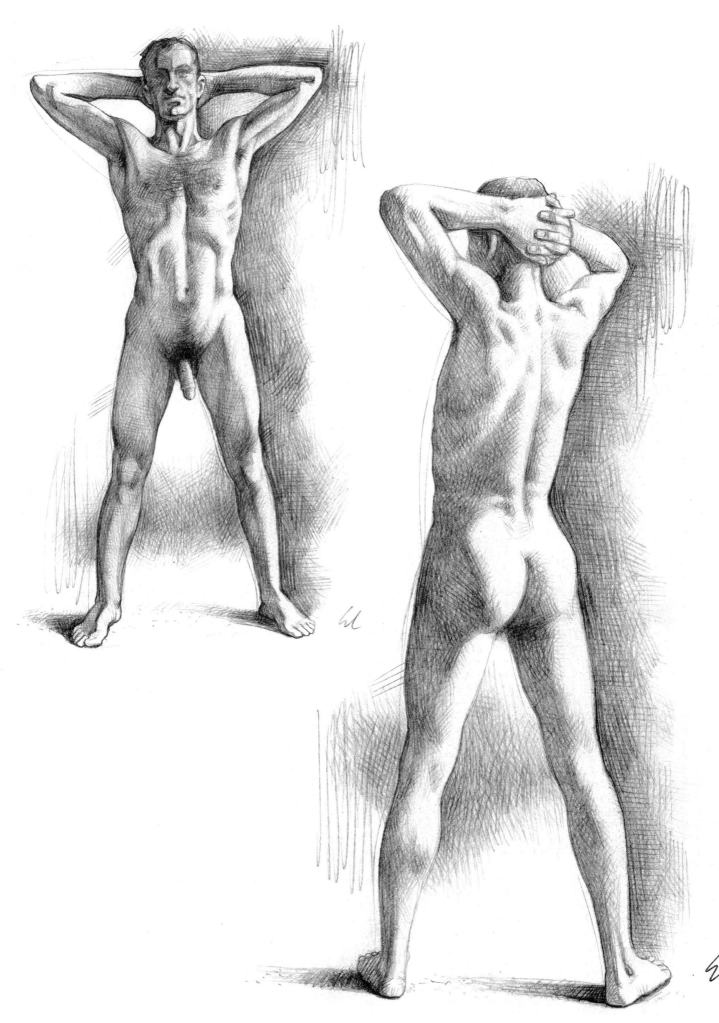

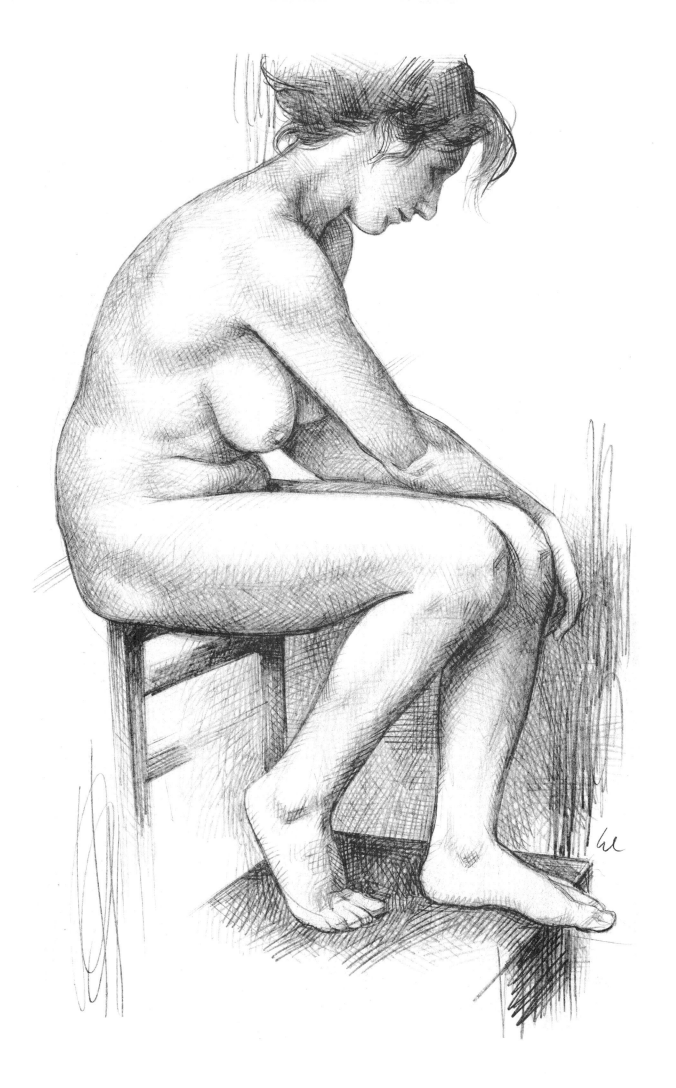

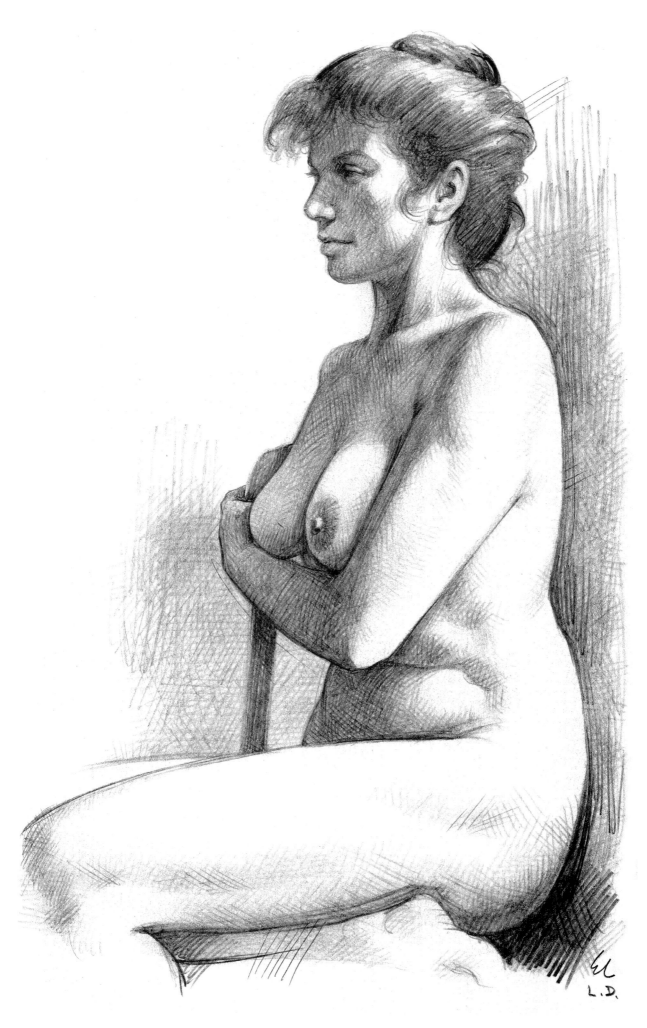

L.D.

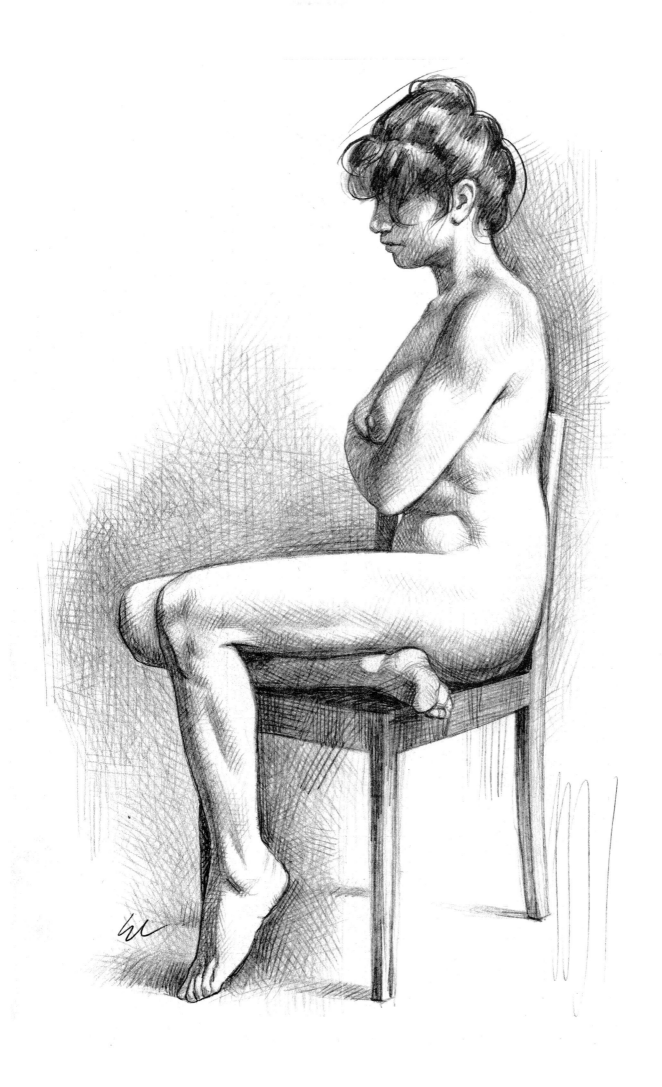

CHOOSING THE POSE AND VIEWPOINT

The choice of *pose* for studying the nude figure depends not only on personal preference but also on the purpose of the drawing and the circumstances in which it is being produced. For example, you may wish to produce a rapid sketch or a very detailed drawing, or you may intend to emphasise the contour lines, the chiaroscuro, the gesture or anatomical features. Sometimes the most expressive choice is suggested by the posture assumed by the models themselves, either intentionally or by chance. Some postures are best described by the male body, others by the female body; in many cases the profile of the body is more suitable for

representing movement, whereas a front (or back) view is more suitable for conveying a state of equilibrium and the tensions involved in maintaining it. Nevertheless, when drawing a nude figure, it can be interesting to do so from different *viewpoints*, turning around the model, so to speak, observing the model from different visual angles, in search of the most favourable, useful or suggestive aspect. An accentuated perspective view can often produce unusual and attractive effects: you can draw the model by placing him or her in a higher or lower position, or you yourself could stand on a raised surface or sit on the floor.

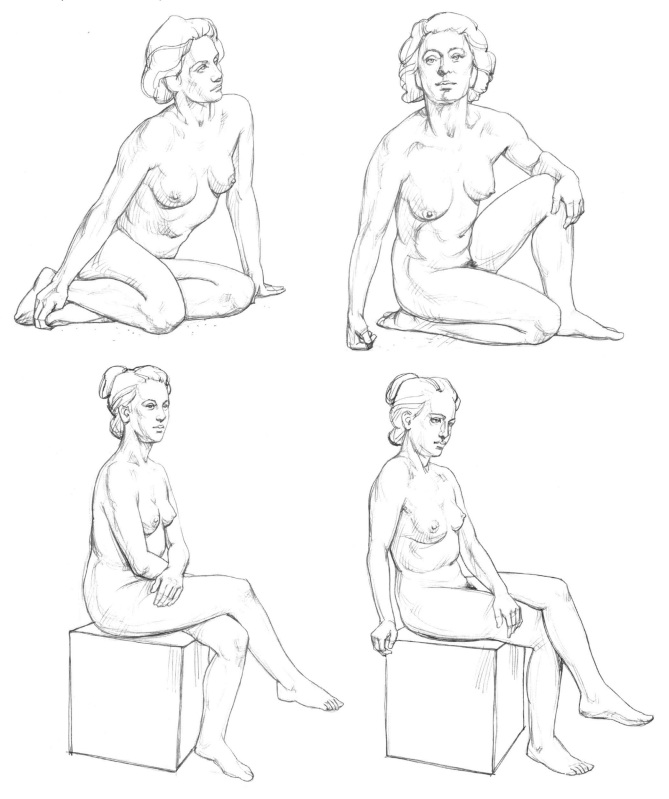

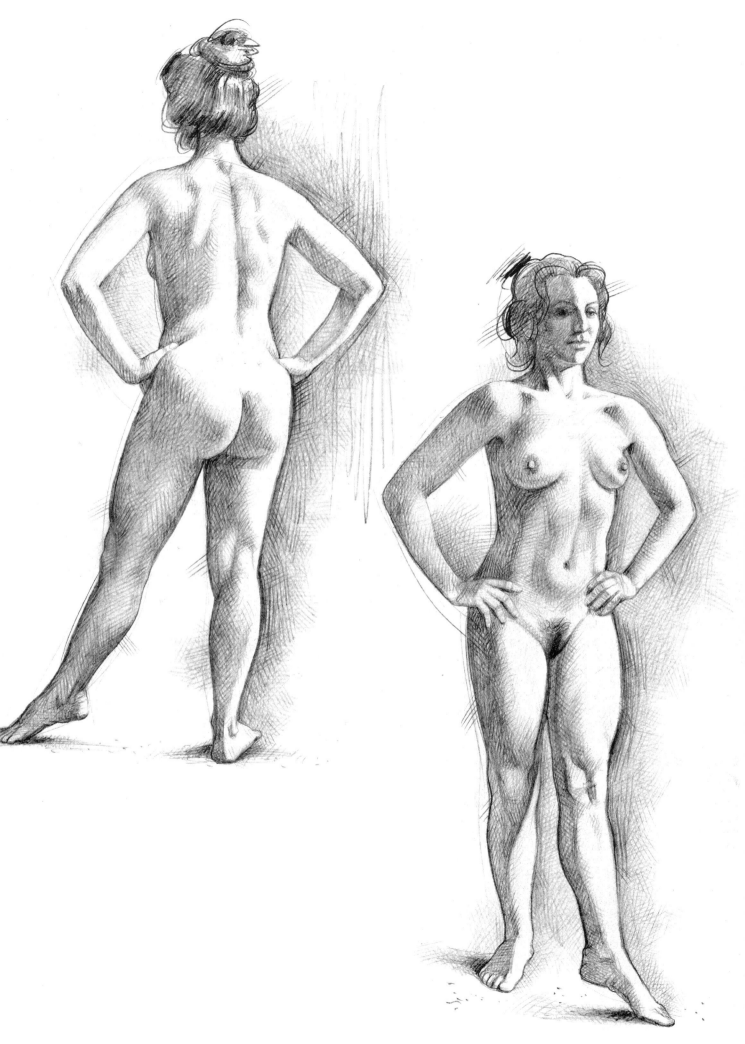

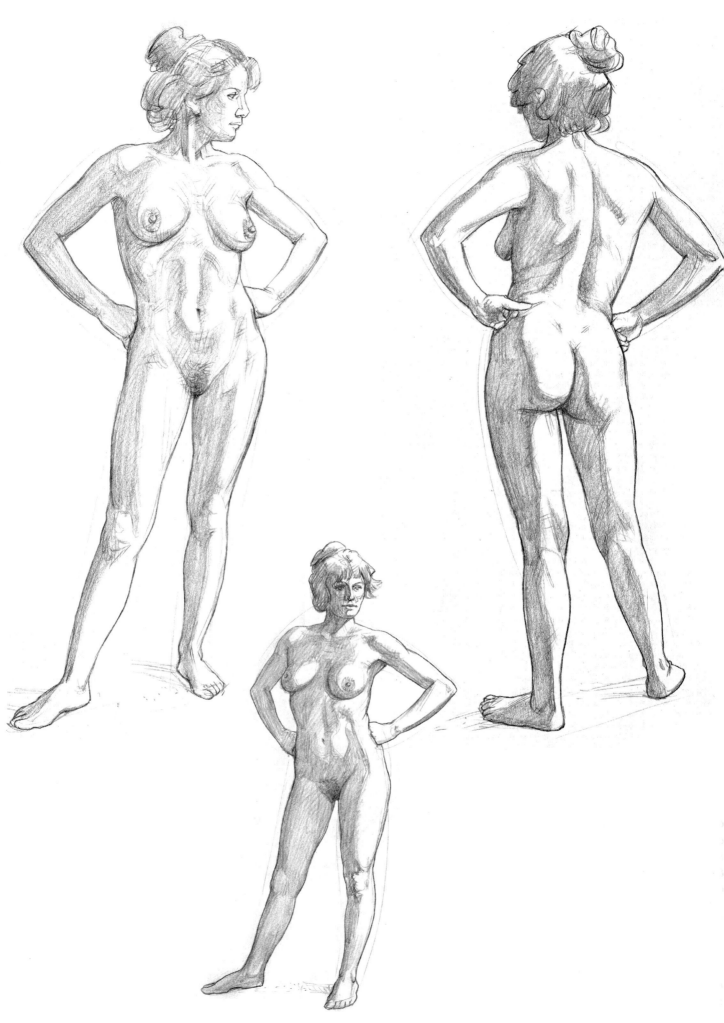

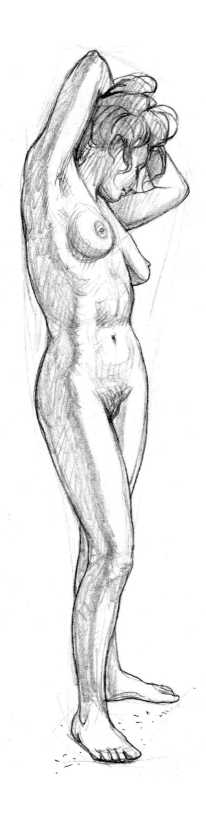

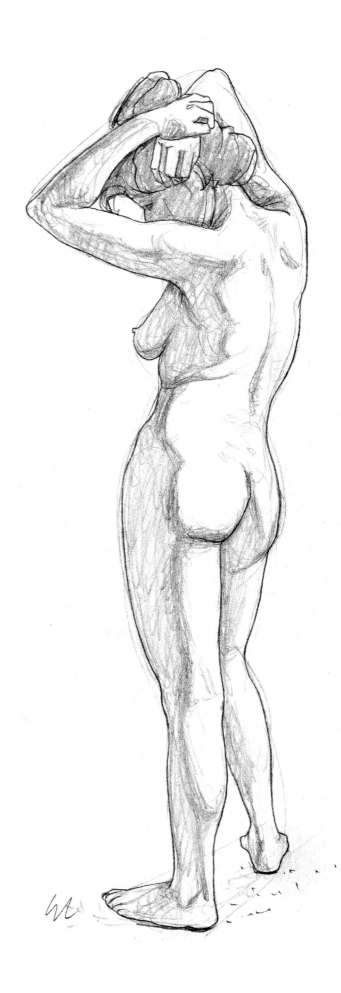

Observing the same pose from different viewpoints is
essential for a sculptor, and it is very useful for the artist
too, satisfying our curiosity about human forms and
translating it into genuinely meaningful drawings. You very
often find that some views of the human body prove
interesting, for example, from an anatomical point of view,
but not so much in terms of the composition or expression,
and that all that is required is a slight shift in viewpoint to
discover a more stimulating aspect. Our opinions are, of
course, subjective, the result of personal taste, refined by
life experiences and culture and also by practising, through
close examination, drawing nude figures from life.

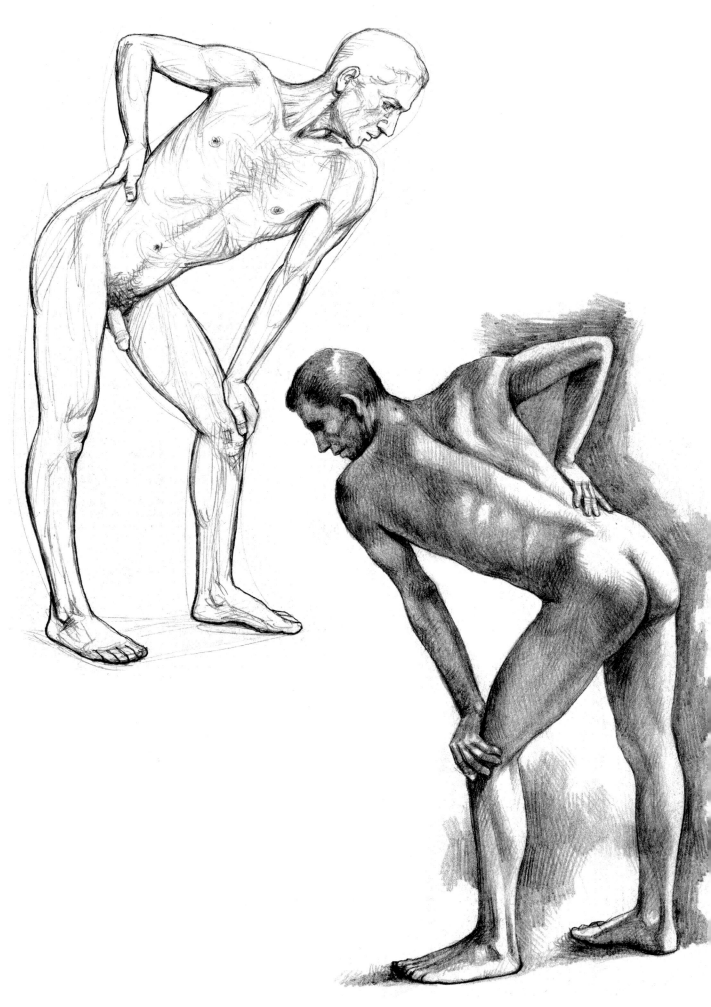

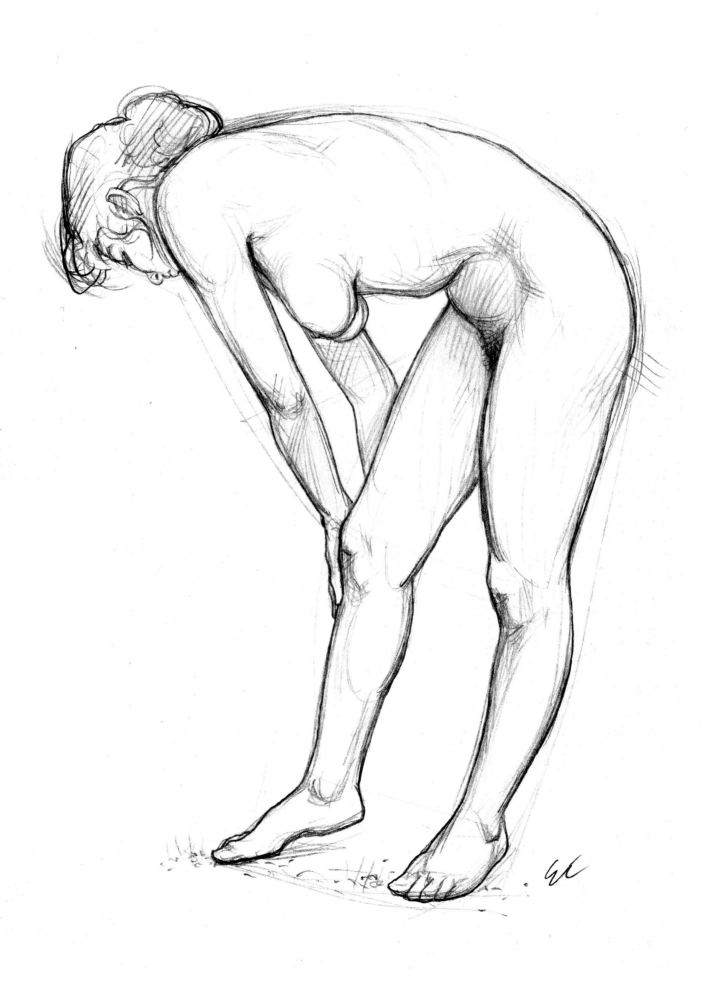

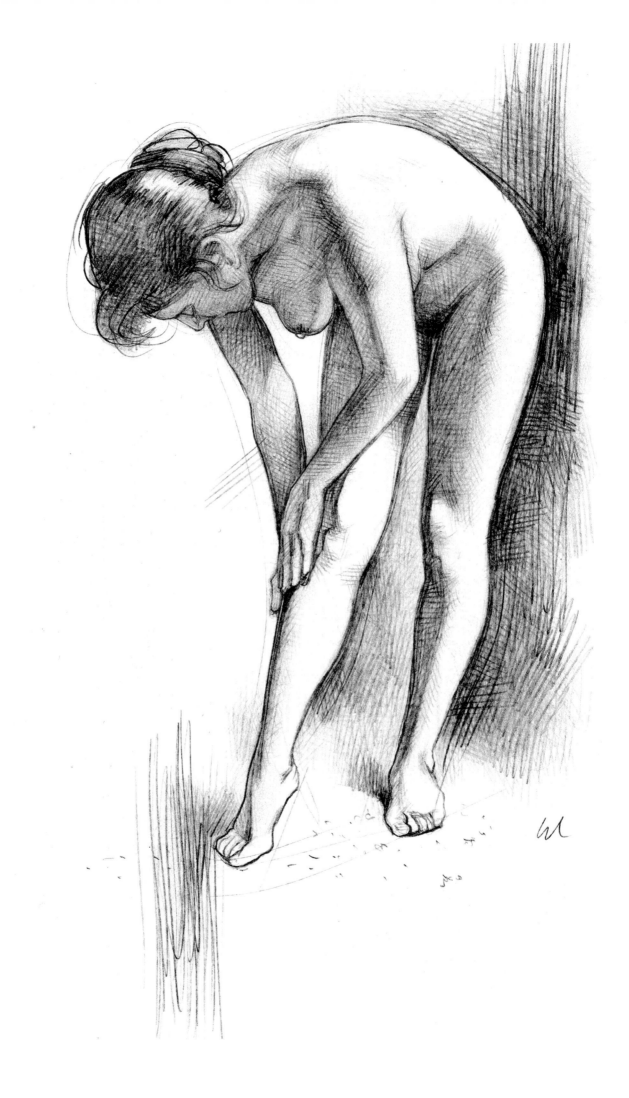

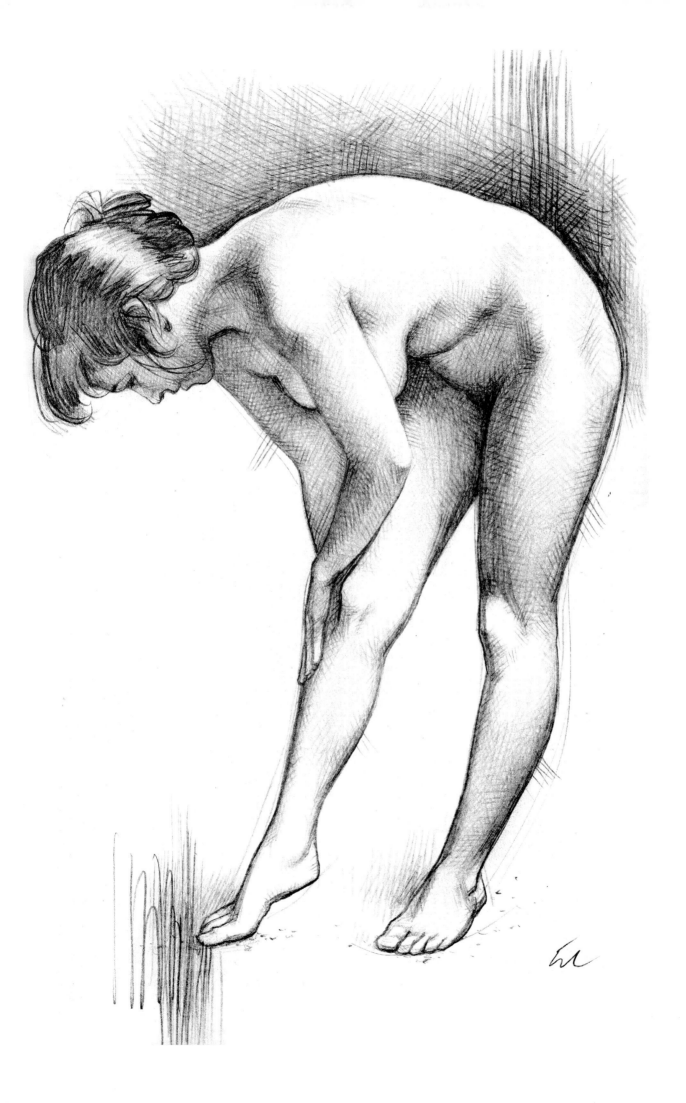

LINE AND TONE

Lines are used to represent the main features of a shape or form (human in our case). Linear drawing is the most synthetic way of depicting objects – it picks out shape and contours, conveying them as linear forms. In fact, lines are an abstract concept, a convention for clearly defining the boundary between a body's surfaces, shadows, masses or structural elements. And yet, depending on how it is drawn (even, broken, continuous, modulated, etc.), a simple line can assume very meaningful and highly expressive aspects. When a human figure's profiles are drawn with just a line, it encourages you to focus on the form's limits and on the most appropriate types of strokes for representing it, intentionally disregarding the less important details that shape the body's surface. But a

purely linear drawing is seldom sufficient to fully define the spatial relationships and volume of the body you wish to portray. To mould the forms effectively, at least according to traditional graphic representation, it is necessary to use *tone* and introduce some chiaroscuro that will indicate the various gradations of shade. For this purpose, it is useful to add, right at the beginning of the drawing, the most important tonal values seen on the model's body and draw them straight away on the whole figure (rather than on individual parts), reducing them to a very limited range, for example: light tone (most intense area of illumination), middle tone and dark tone (most intense area of shadow).

As well as drawing the contours of the external forms, it is useful, and sometimes necessary, to draw the profiles of some 'internal' forms (parts of the face, etc.) in a synthetic way, concentrating on the most meaningful anatomical characteristics in relation to the posture concerned. Linear drawing, in short, should not 'flatten' body forms and make them merely decorative, but should suggest their solidity and volume.

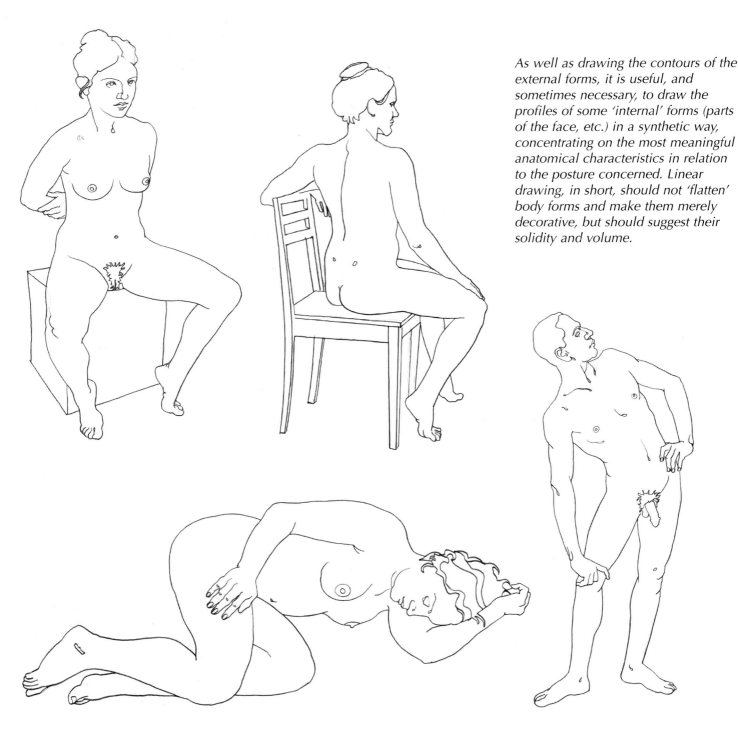

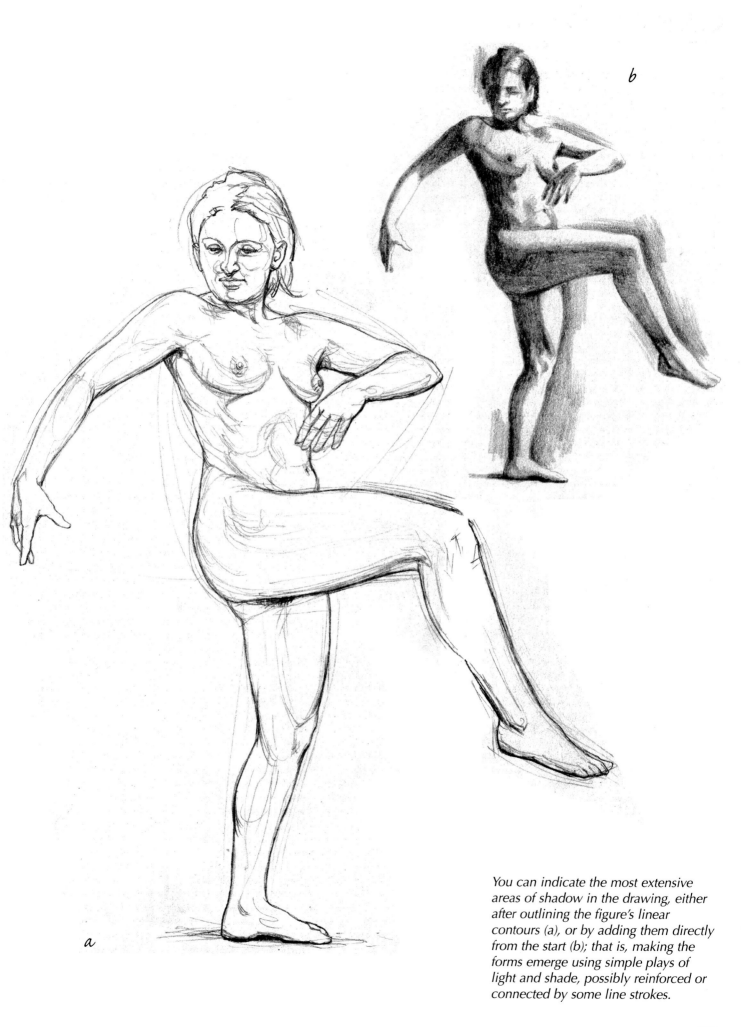

You can indicate the most extensive areas of shadow in the drawing, either after outlining the figure's linear contours (a), or by adding them directly from the start (b); that is, making the forms emerge using simple plays of light and shade, possibly reinforced or connected by some line strokes.

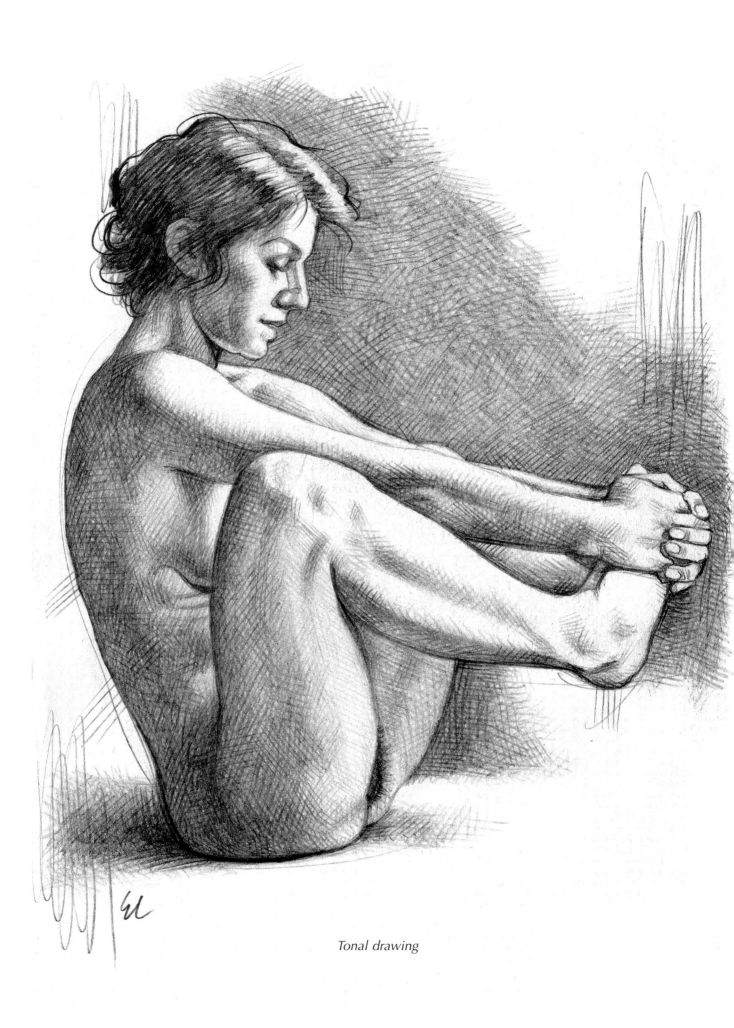

Tonal drawing

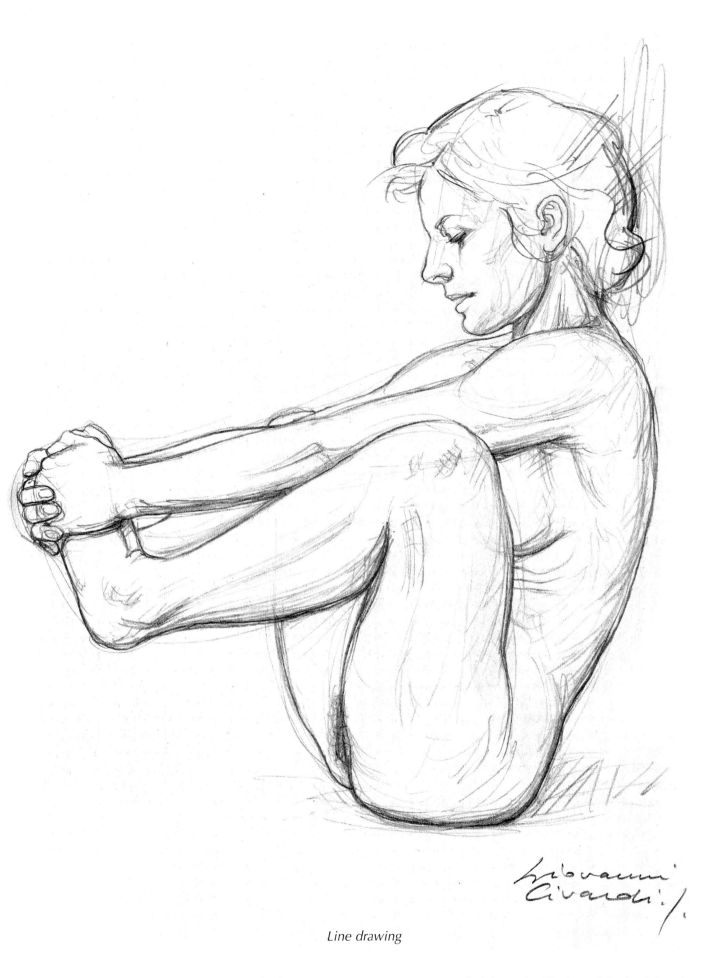

Line drawing

Shading, using its various tones, can heighten the illusion of the body's volume and position in space. You can, of course, combine the two extreme methods (pure linear drawing and pure tonal drawing) to varying degrees.

RHYTHM

A line's progress can vary or be interrupted at regular intervals and acquire a rhythmic value. *Rhythm* is something that repeats itself at cyclic and definite intervals: it is very common in nature and you can see it in the forms of the human body. For example, a small curve alternates with a larger one, a convex profile with a concave one, and so on. It is interesting and useful to identify the relationships between alternating lines in any body position, which give the figure rhythmic scansion, organic unity or a flow of lines and forms. Varying forms and alternating directions eliminate the monotony of visual uniformity; even the structural axes of the various segments, if they have a dominating sense of direction, can configure and express the potential 'forces' that suggest equilibrium, tension or dynamic effect. However, rhythm is not only found in lines, but also in other components that help structure the composition of a drawing, painting or sculpture: for example, in tone, colour, volume or the layout of elements with 'visual weight', etc.

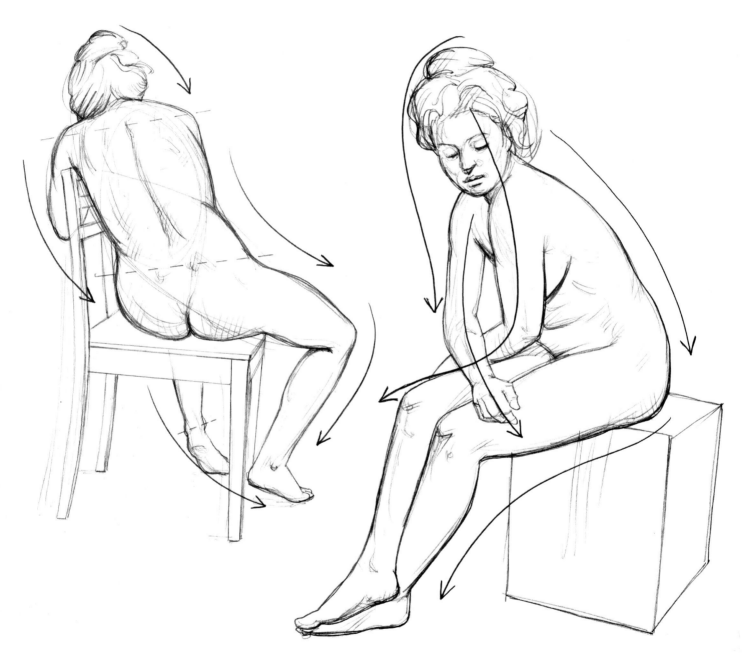

The rhythm of the pose is marked by an 'internal' line that runs along the entire length of the body, and follows the posture adopted by the figure or the movement it is making. In the human body, moreover, the shapes of the limbs are connected with the shape of the trunk: rhythm is seen in the way in which each part is joined to the next one and how all the parts come together in the whole body.

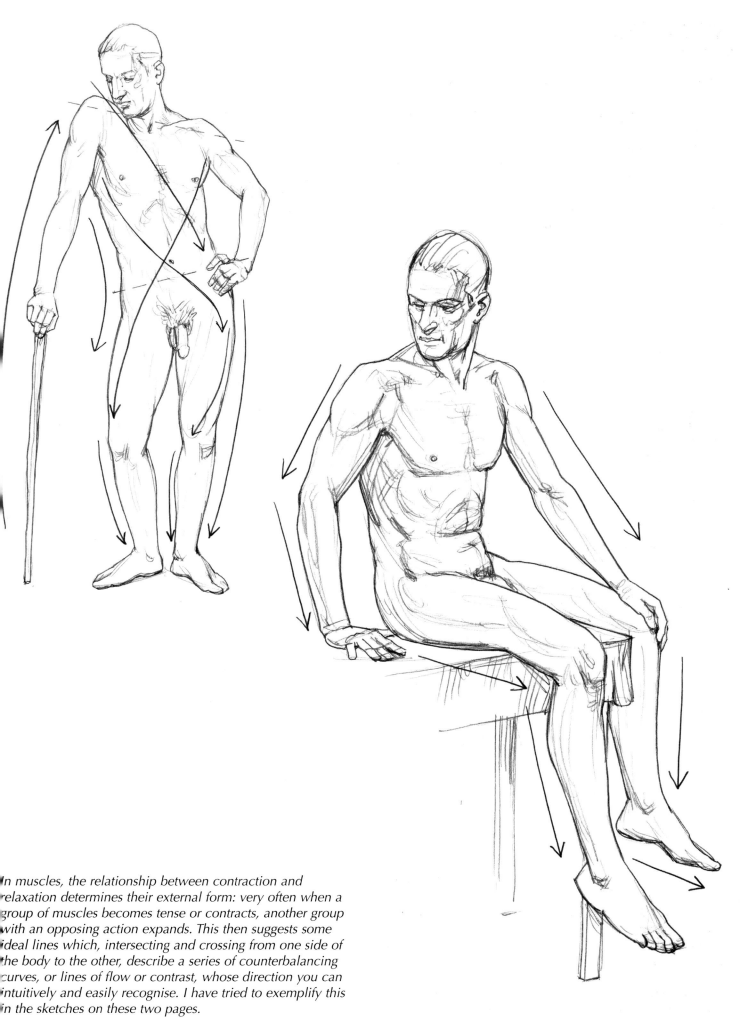

In muscles, the relationship between contraction and relaxation determines their external form: very often when a group of muscles becomes tense or contracts, another group with an opposing action expands. This then suggests some ideal lines which, intersecting and crossing from one side of the body to the other, describe a series of counterbalancing curves, or lines of flow or contrast, whose direction you can intuitively and easily recognise. I have tried to exemplify this in the sketches on these two pages.

GRAVITY

The force of gravity attracts objects downwards and can be said to act through the centre of gravity (or barycentre) of an object. The position of the centre of gravity above the base of the body affects that body's equilibrium. We also need to consider other aspects of gravity. The body's external shape is determined by a rather rigid support structure, the skeleton, and by tissues of various thicknesses, the so-called 'soft tissues', such as the skin, muscles, fat, etc. The force of gravity does not alter the appearance of the bones, acting on them only to make the individual skeletal components adjust their balance as a result of the body's position at a particular time. However,

as is clear from general observation, the shape of soft parts does change. In women, the changes are perhaps more obvious and easily noticed: hair, breasts or stomach, for example, compress, expand, lengthen or sink into the trunk depending on whether the model is lying face down, is on her back, is standing upright or lying on one side or, even standing on her head. The soft tissues, moreover, adapt to the shape of the support or to another part of the body with which they are in contact. The extent of the adaptation correlates to the solidity of the support and the level of compression of the organic tissue.

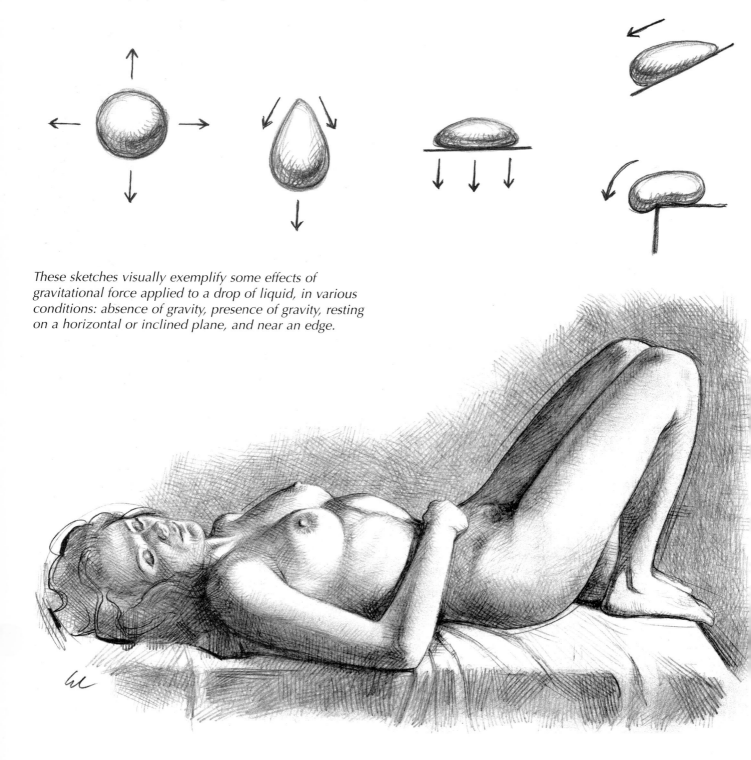

These sketches visually exemplify some effects of gravitational force applied to a drop of liquid, in various conditions: absence of gravity, presence of gravity, resting on a horizontal or inclined plane, and near an edge.

SKETCH AND STUDY

Your observation of a subject changes depending on how you want to draw it. When drawing nude figures you can explore different aspects, for example, composition, anatomy, expression, structure or chiaroscuro. You could employ different types of drawing along the way towards your final drawing, which may be an end in itself or a preparatory study for a complex work. In practising drawing the human figure, we can identify two principal means for learning and improving: sketches and studies, which are different in their conception, purpose and end result.
A *sketch* is the first rapid, synthetic note, which fixes the preliminary idea for a planned composition or interesting physical pose. In its most fundamental form, a sketch can coincide with a 'gestural' drawing (cf. page 6) and encourage the artist to identify the main lines of the form

immediately and synthetically, without worrying about the drawing's apparent incompleteness. It consists, in short, of taking the first notes inspired by the model's spontaneous, casual pose or a precise posture that you wish to investigate, aspects that seem worthy of closer examination in more elaborate studies from life.
A *study*, however, is the task of observing, of carefully recording and analysing some aspects of the figure: anatomic structure, proportions, the 'character' of the pose or effects of light and shade. A thorough investigation of the study is also reflected in a more meticulous technical rendering, produced with the most appropriate graphic tools for conveying the form's particular features, and assessing the effectiveness of different aesthetic solutions.

DRAPERY

Drapery provides excellent opportunities for studying aspects of volume on the human figure. It is an ideal tool for accentuating the shape of some parts of the body. In a paradoxical way, drapery actually enhances nudity. At the same time, it can minimise other body shapes and can also become a composition tool. The direction of the folds, the shadows that these produce, the way in which the fabric is supported by the skin in some places, causing it to billow out and yet adapt to the figure, and the way it falls to the ground under the influence of gravity, are all factors that influence the artist when arranging the composition of the whole figure. In making a study of the draped figure, it can be advantageous to consider the following points. First, the weight, thickness and density of the fabric determine the quantity, size and direction of the folds. Choose quite a light fabric so that it does not hide the anatomical forms (which should be allowed to 'show through' to some extent). Second, when starting to draw the fabric, it is a good idea to draw the most meaningful and important folds, following their direction clearly and surely, so as to suggest the presence of the body shape they cover. Third, a figure that is only partially covered by drapery offers a further advantage over one that is fully covered or dressed in everyday clothing: it enables us to recognise more easily the anatomical regions that support the fabric and give rise to the folds, or the diarthrodial joints from which the creases fan out.

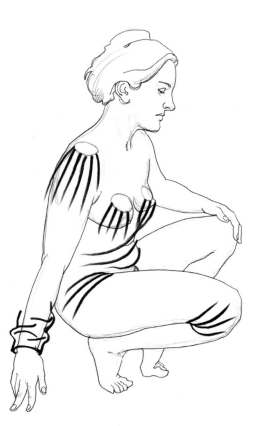

This sketch shows the difference in folds from some supporting or bending regions of the body. Ancient Greek sculptures provide numerous examples of drapery, which are both the result of invention and careful observation from life. I recommend that you do some research into the various artistic styles used for depicting drapery in different civilisations.

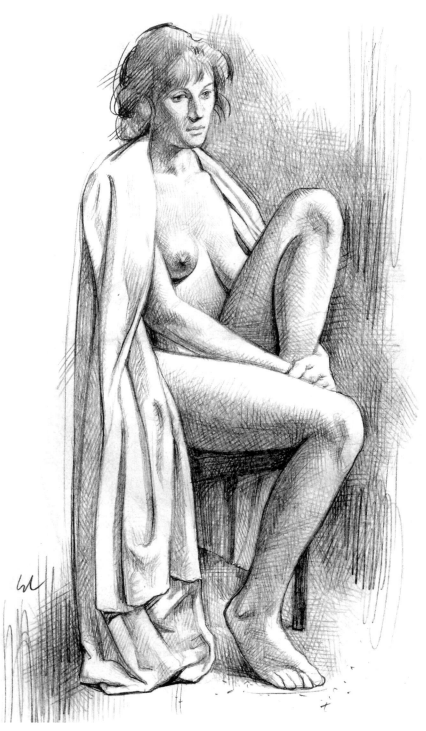

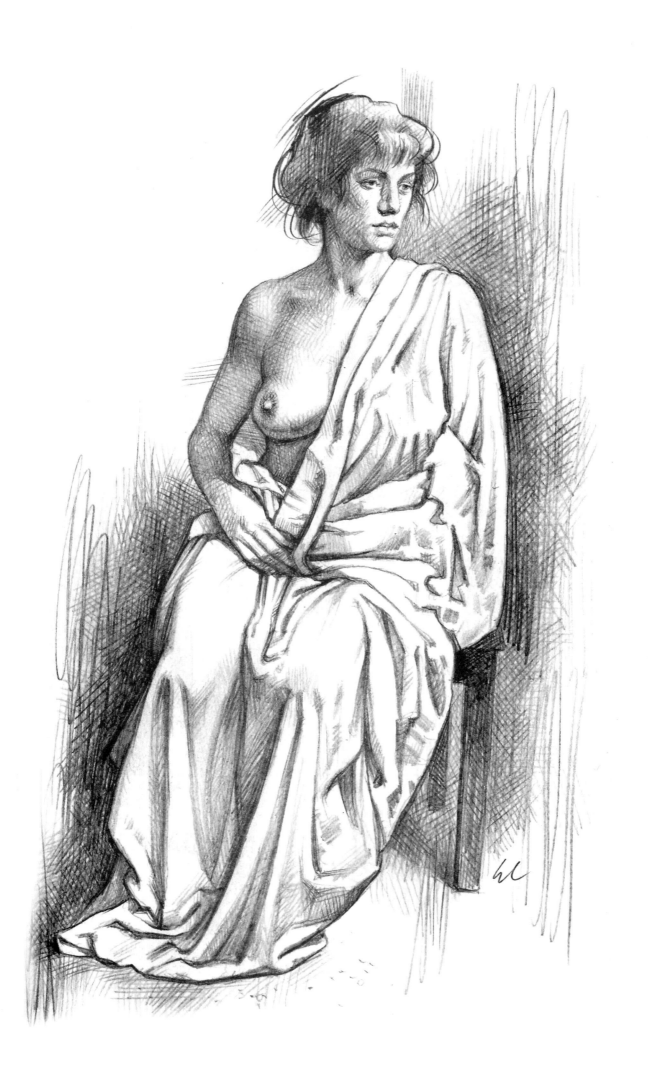

STATIC AND DYNAMIC POSES

In this section of the book, I have selected a small series of drawings taken from my notebooks of studies from life*, a short selection of poses that you could ask your models to assume during nude sittings; you could use these poses as a basis from which to make changes, for example, to the lighting, viewpoint or state of motion. The variety of positions and postures of the human body that attract the artist's attention is, of course, unlimited, although these positions and postures can be placed in some wide, general categories: standing upright, sitting, reclining, etc. Each category has abundant subcategories. The term 'dynamic' usually implies activity, movement of the body, and we know all too well how difficult it is to perceive and draw a moving object correctly. You need to observe the actual development of the movement very carefully, and it is better if it is repeated several times, to aid the capture of the most meaningful and effective 'changes' and to express the direction and coherence of the movement. Alternatively,

you could refer to photographic and film footage, even though, with these tools, perspectives seem highly distorted and the movement is 'frozen' in a sequence. This is useful for understanding the anatomical mechanism of the action, but not very well suited to an overall and coherent perception of the completed gesture. Therefore, I prefer to indicate with 'dynamism' a sort of *tension* in the forms or axes, forces of expansion, contraction or torsion, which animate the body and allow signs of vitality, energy and vigour to show through it. These feelings are, however, rarely suggested by positions that I call 'static', of which calm, equilibrium and relaxation are the main characteristics. The drawing of a posed body assumes either a mainly static or mainly dynamic characteristic with the help, in short, not only of the model's postural and anatomical appearance, but also by variations in the symmetry or asymmetry, equilibrium, chiaroscuro, composition or rhythm, as discussed on previous pages.

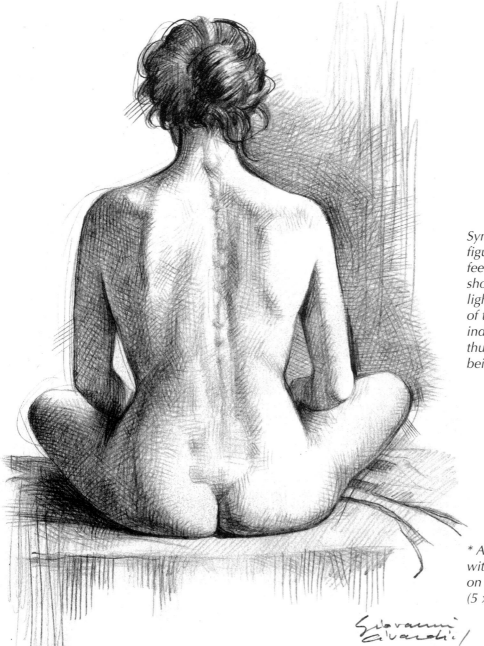

Symmetry and equilibrium render the figure perfectly stable and also allow a feeling of meditative tranquility to show through in the drawing. A lateral light, however, can shape the surfaces of the back, emphasising any slight indentations and protuberances, and thus prevent planes and tonalities being monotonous.

** Almost all the sketches were drawn with a 0.5mm HB micro lead pencil, on paper measuring 13 × 20.7cm (5 x 8in) (Moleskine notebooks).*

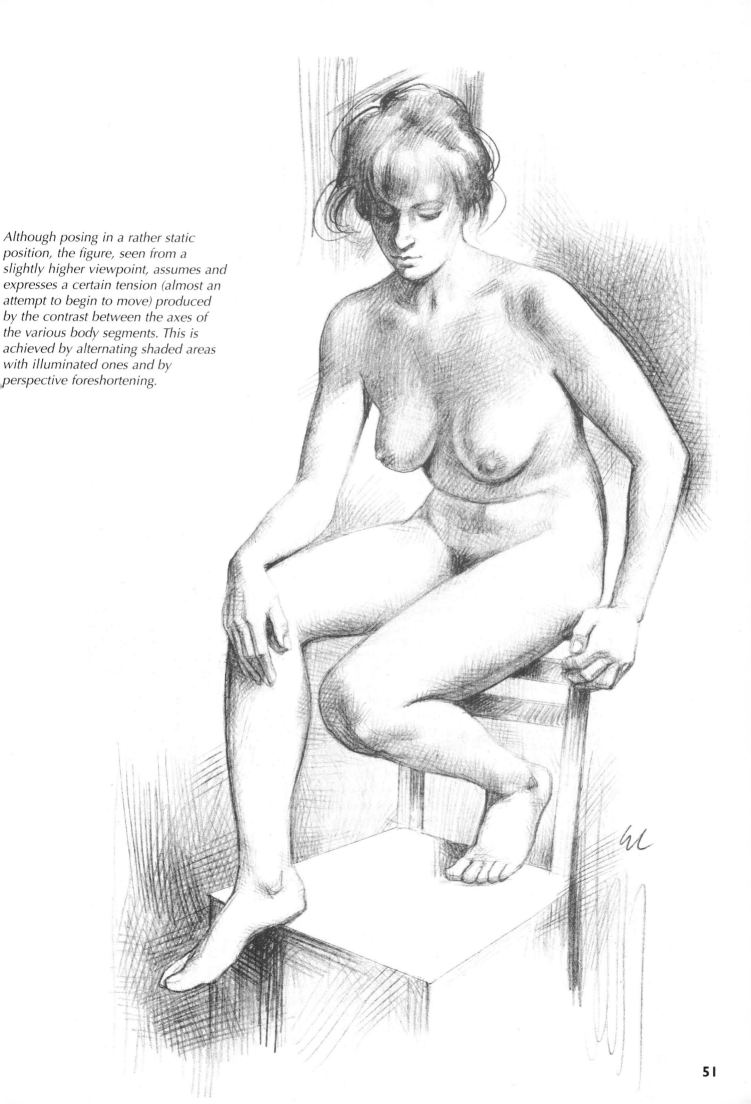

Although posing in a rather static position, the figure, seen from a slightly higher viewpoint, assumes and expresses a certain tension (almost an attempt to begin to move) produced by the contrast between the axes of the various body segments. This is achieved by alternating shaded areas with illuminated ones and by perspective foreshortening.

When you have the opportunity to work with models who have had gymnastic training, it is very easy to capture, in their spontaneous postures, a dynamic characteristic, a tension between opposing forces. See, for example, this pose, where the contraction of the muscles in the back, abdomen and thighs tends to oppose the gravitational pull exerted on the trunk and head bent forwards.

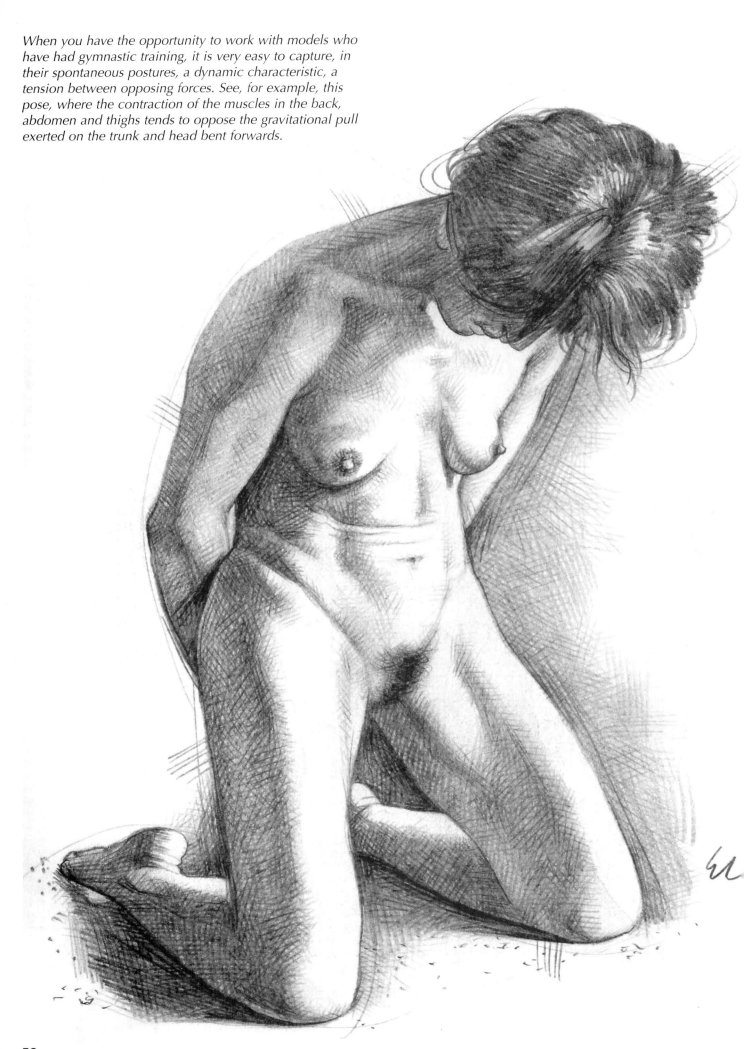

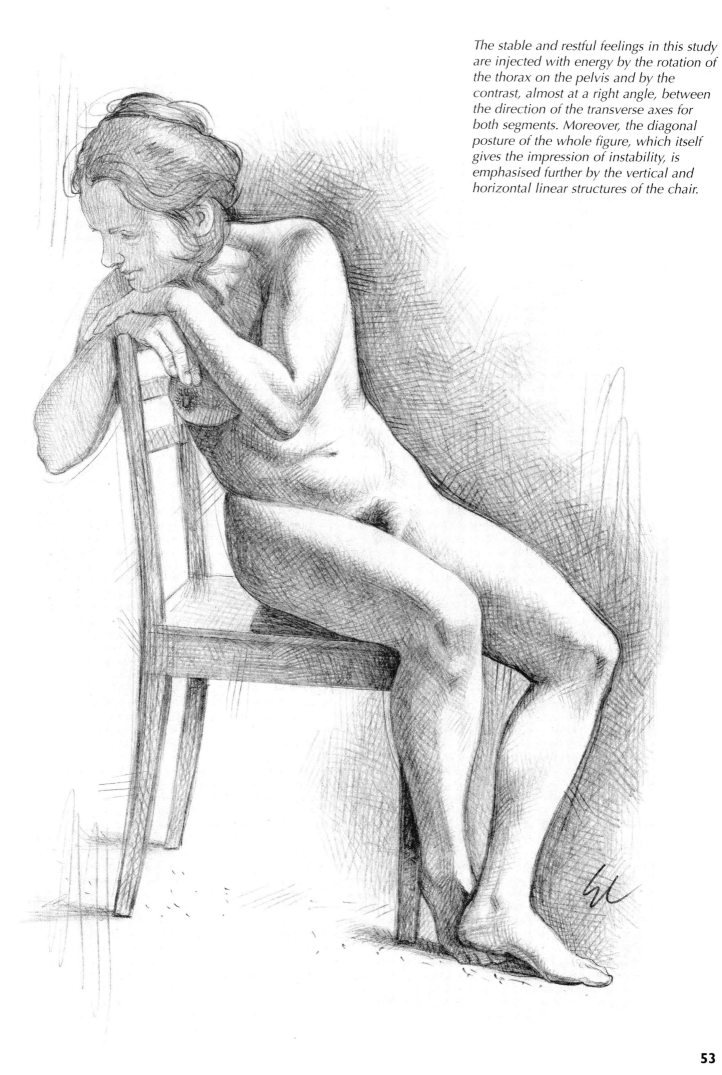

The stable and restful feelings in this study are injected with energy by the rotation of the thorax on the pelvis and by the contrast, almost at a right angle, between the direction of the transverse axes for both segments. Moreover, the diagonal posture of the whole figure, which itself gives the impression of instability, is emphasised further by the vertical and horizontal linear structures of the chair.

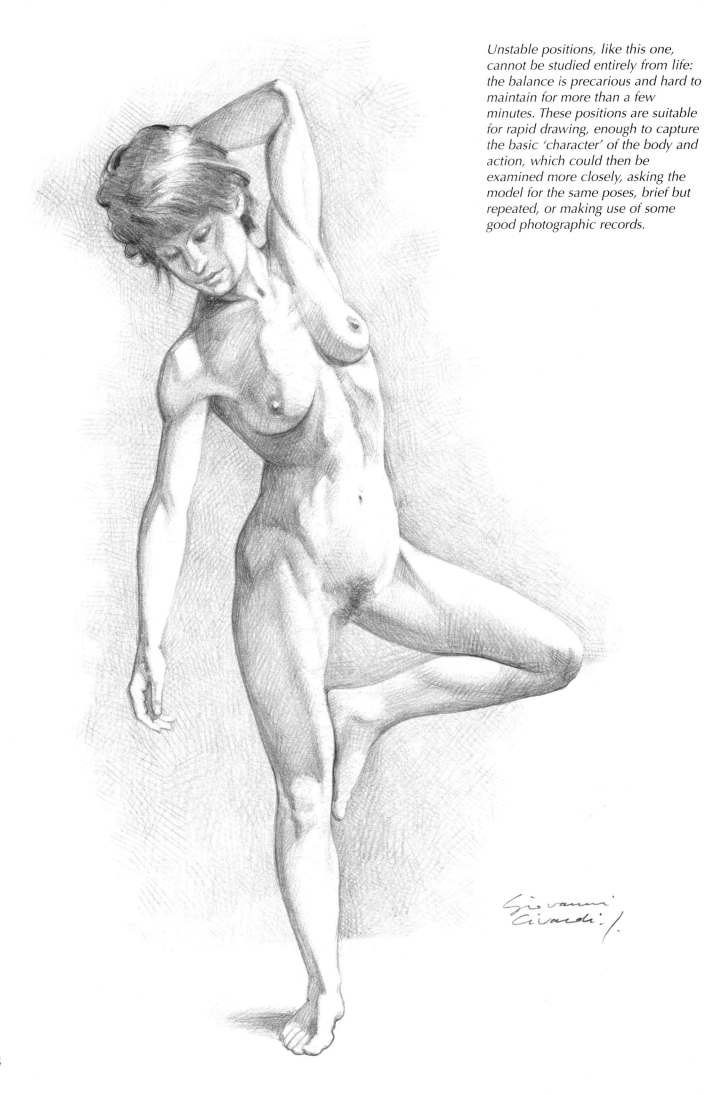

Unstable positions, like this one, cannot be studied entirely from life: the balance is precarious and hard to maintain for more than a few minutes. These positions are suitable for rapid drawing, enough to capture the basic 'character' of the body and action, which could then be examined more closely, asking the model for the same poses, brief but repeated, or making use of some good photographic records.

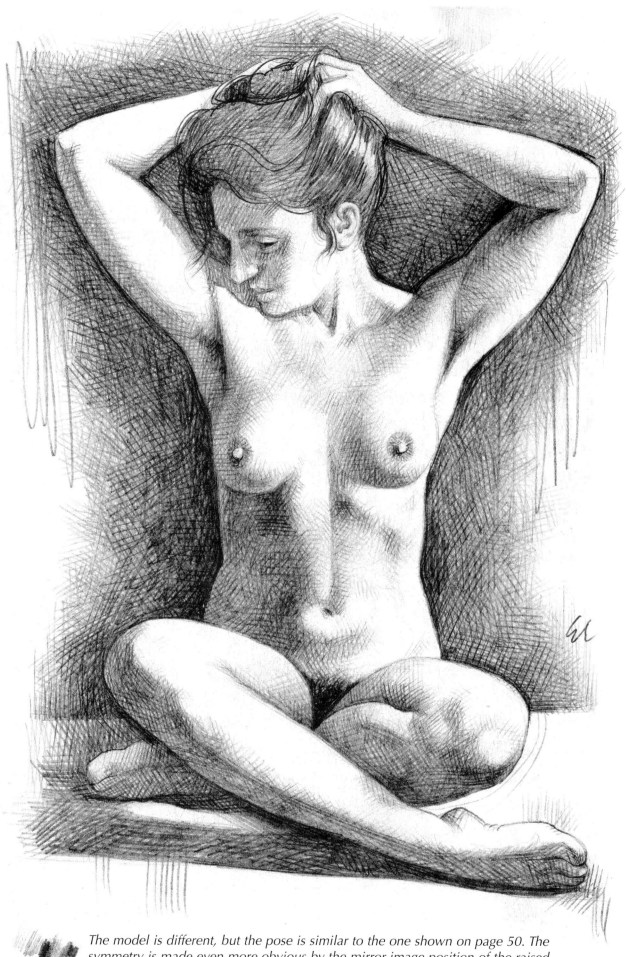

The model is different, but the pose is similar to the one shown on page 50. The symmetry is made even more obvious by the mirror-image position of the raised arms, and yet this contrasts with the rotation of the head, so much so that we see almost a profile of the face. A further contrast is the very slight difference in position and shape of the breasts, which, it is useful to remember, are twin body parts that are rarely perfectly symmetrical.

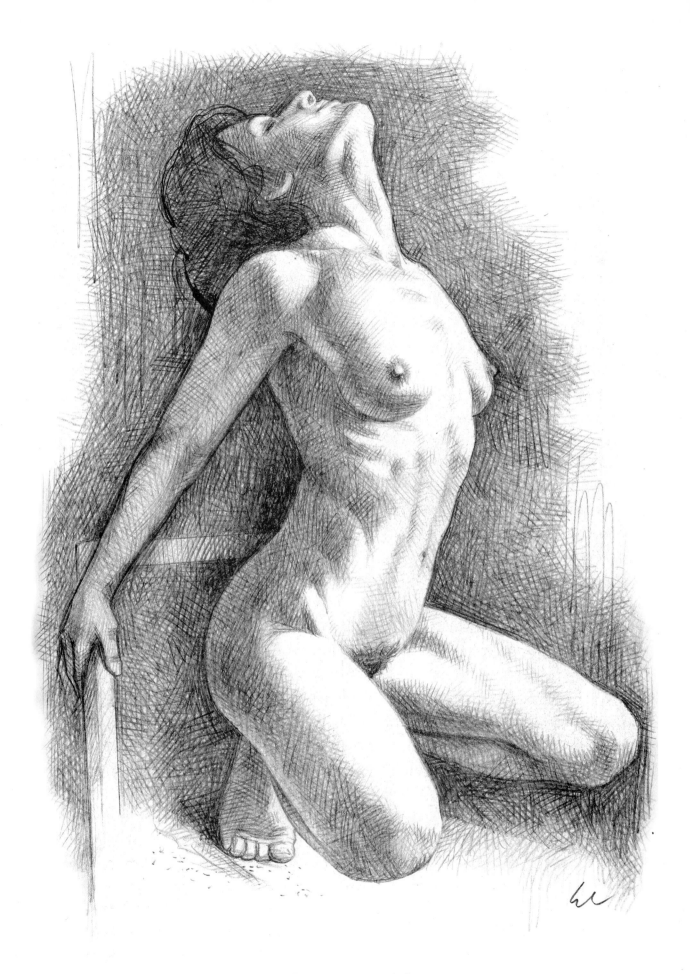

Despite appearances, this position is still rather static. The tensions mainly lie in the composition and chiaroscuro. In fact, the drawing was produced entirely from life, with the model posing for the whole time, about half an hour. According to the model, she did not even get very tired.

The posture shown here is a typical 'pose': i.e. the model has assumed a position that was once defined as having a 'sculptural' quality, aimed at emphasising the play of muscles and the effects of light and shade that enhance it. Any evidence of static form or dynamism seems, therefore, somewhat artificial and showy, or, as in this pose, present at the same time: the pyramidal arrangement of the body contrasted with the lateral twist of the thorax, the rotation of the head, the position of the arms on the same oblique line, the contraction of the thigh muscles, and so on. These poses are, however, worth studying because the model can maintain them for quite a long time and they allow a close analysis of the surface muscles.

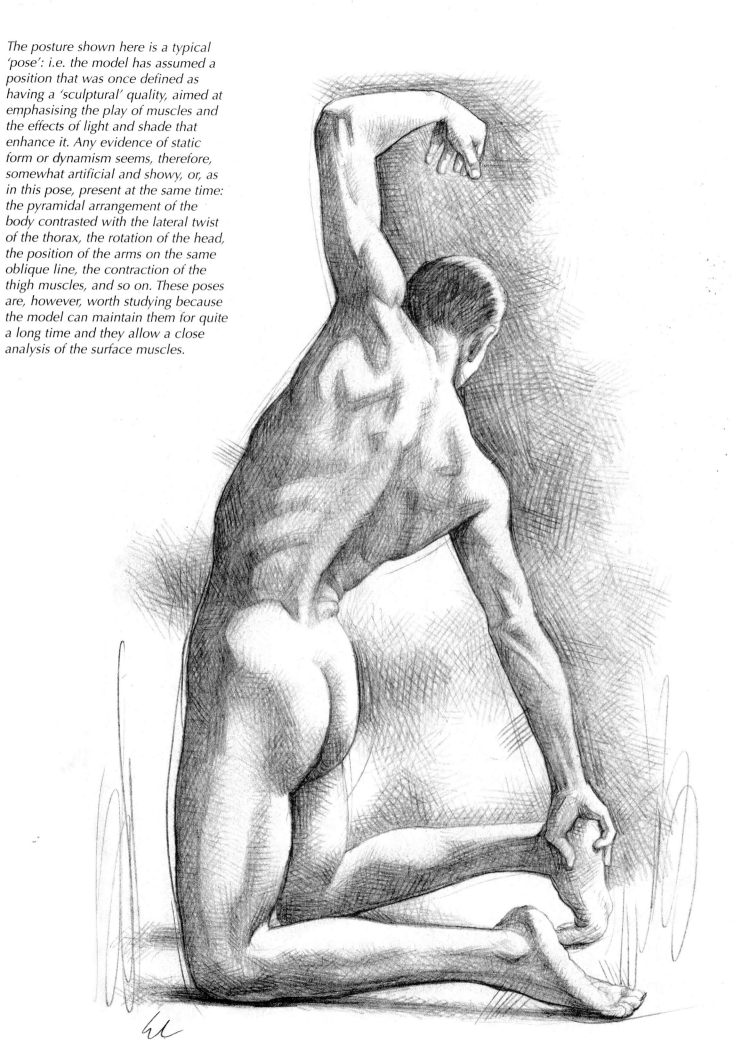

Sometimes, the positions assumed by the body can be placed into one of two categories: 'open' or 'closed'. Open forms are those associated with the appearance and feeling of expansion, divergence or spreading out of the body segments towards the surrounding space, as if they were driven by centrifugal forces. Closed forms, on the other hand, seem to express a sense of concentration, condensing, as if the body's segments were being drawn in by a centripetal force. The position drawn here is a very closed one, which is conveyed by the joining of the hands and interlacing of the fingers. But it also suggests 'explosive' tension, caused by the twisting of the thorax and emergence of the left knee, whose relationship with the other body parts is not easy to judge, at least at first glance.

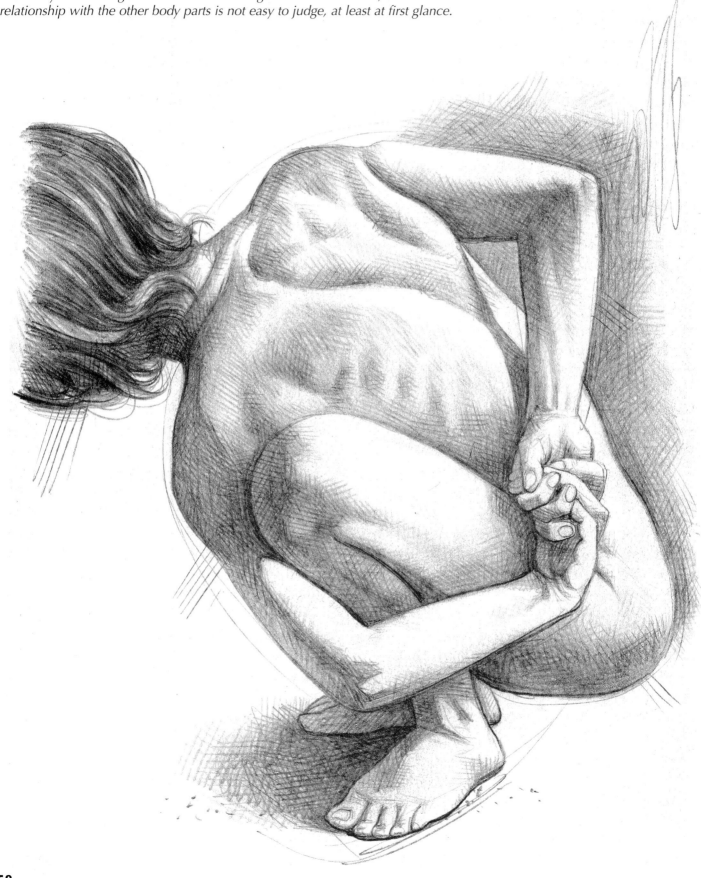

When a closed action is in progress, it results in a decidedly dynamic drawing, in the widest sense of the term. If you do not wish to use photographs or poses repeated over and over, it is quite difficult to make an accurate study of these positions. Even if the action is simply slowed down, it breaks up and alters the sequence of the gesture and reduces its natural, spontaneous flow. The artist and the model, therefore, are forced to use their imagination and creativity for the drawing, finding an acceptable compromise and the best way of 'stopping' the movement: after a quick drawing that fully captures the character of the gesture and the anatomical forms that define it, and after a few photographs for reference, they have to devise some means of support so that the model can maintain the pose (although with a partial loss of tension and spontaneity), for at least a few minutes. The model portrayed in this drawing, for example, was 'sitting' on the arm of an easy chair and was resting her fingers on a cardboard box.

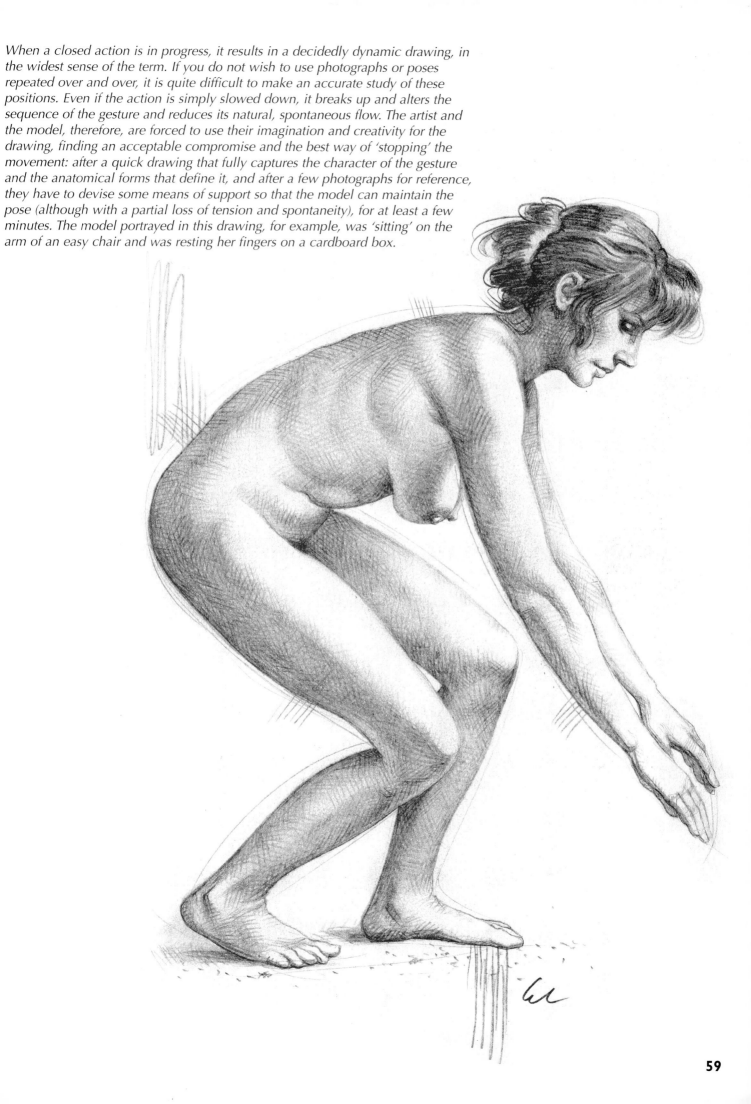

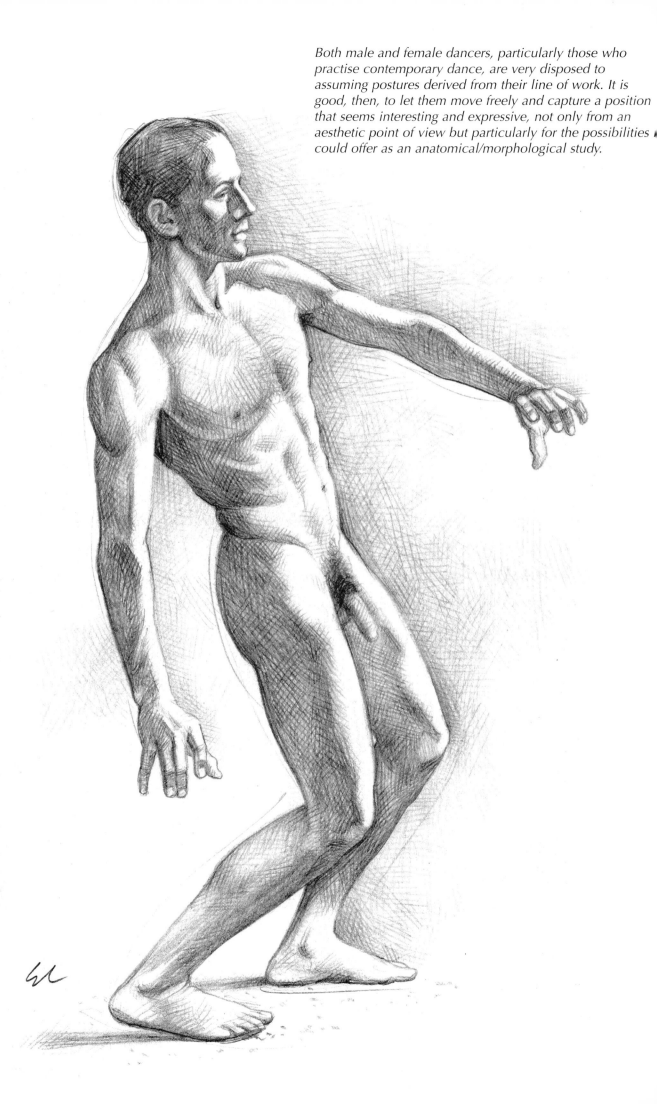

Both male and female dancers, particularly those who practise contemporary dance, are very disposed to assuming postures derived from their line of work. It is good, then, to let them move freely and capture a position that seems interesting and expressive, not only from an aesthetic point of view but particularly for the possibilities could offer as an anatomical/morphological study.

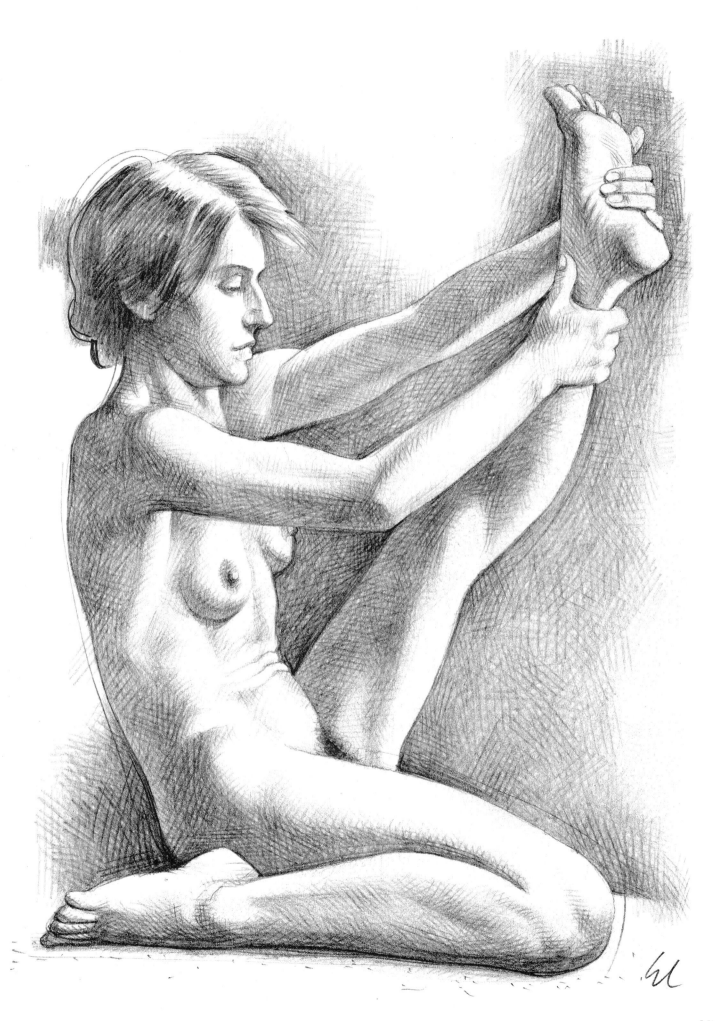

This is another 'closed' form, posed by the same model who appeared in some earlier drawings and who is particularly skilled at assuming athletic positions. In these cases, however, it is preferable not to accentuate any muscle bulges or the denseness of the shadows they cast. It is better, instead, to depict the muscles correctly according to the intensity of the action being carried out.

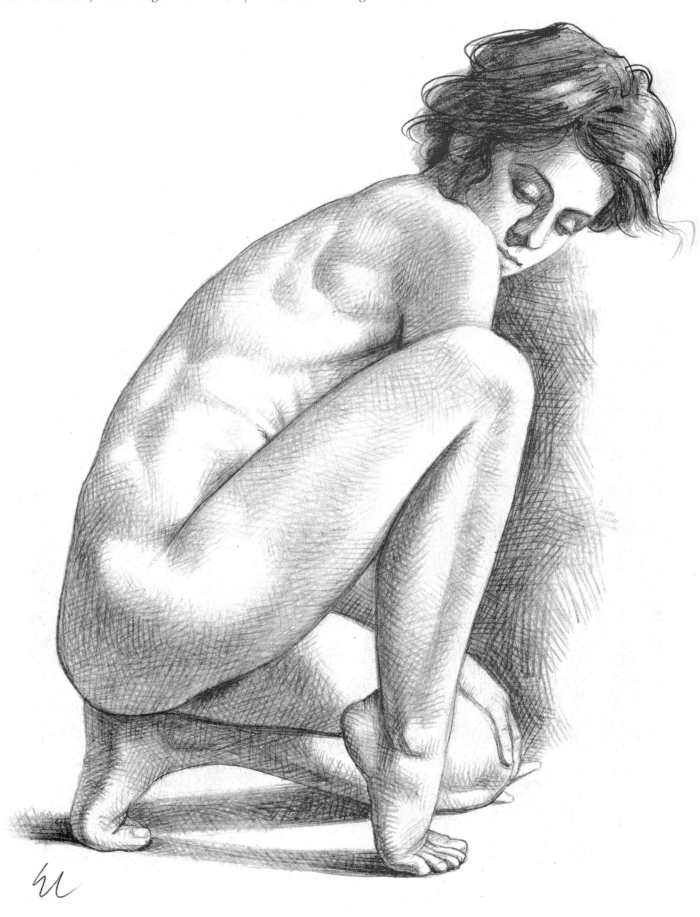

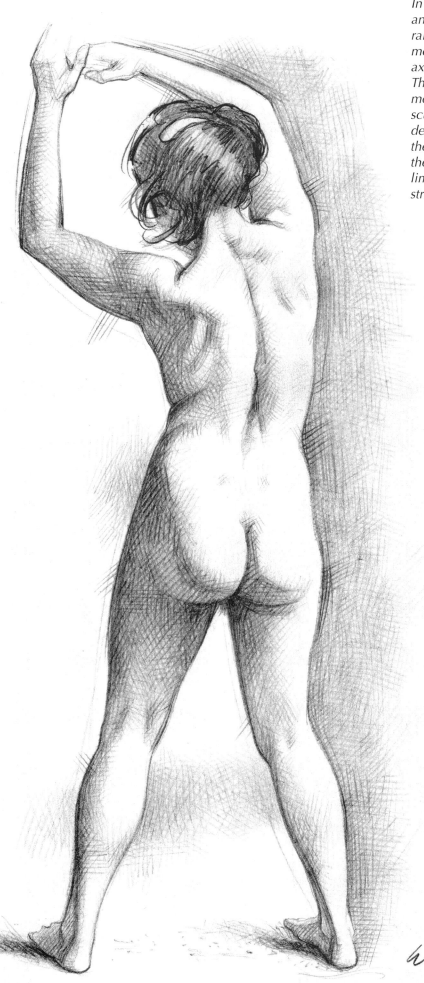

In this pose the model has assumed an open configuration: with her arms raised and legs outstretched, they move away from the trunk, the main axis, centred on the pelvis and spine. This axis, in fact, should receive the most attention, when drawing or sculpting nude figures, because we derive the fundamental character of the body's posture from it. It describes the body's position in space; also the limbs and head, of secondary value structurally, stem from it.

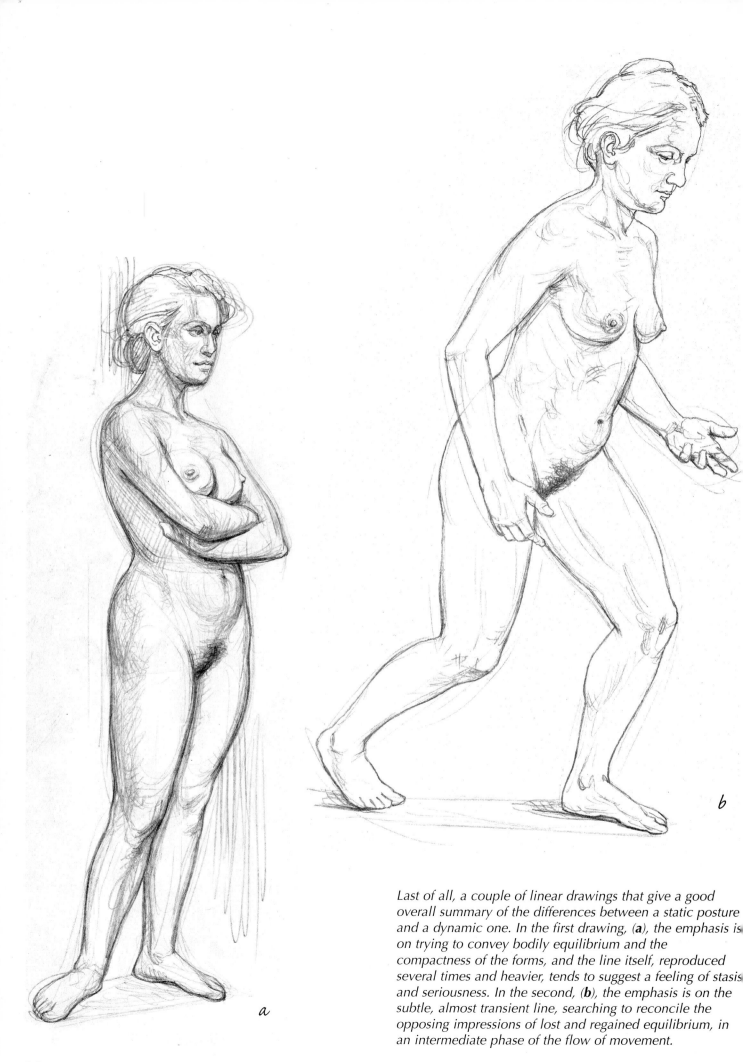

Last of all, a couple of linear drawings that give a good overall summary of the differences between a static posture and a dynamic one. In the first drawing, (**a**), the emphasis is on trying to convey bodily equilibrium and the compactness of the forms, and the line itself, reproduced several times and heavier, tends to suggest a feeling of stasis and seriousness. In the second, (**b**), the emphasis is on the subtle, almost transient line, searching to reconcile the opposing impressions of lost and regained equilibrium, in an intermediate phase of the flow of movement.